£1.99

D0006835

THE ART OF
CLASSICAL GREECE
AND THE ETRUSCANS

THE ART OF CLASSICAL GREECE
AND THE ETRUSCANS

General Editor
Francesco Abbate

Translated by
Enid Gordon

Octopus Books

London · New York · Sydney · Hong Kong

English version first published 1972 by
Octopus Books Limited
59 Grosvenor Street, London W1
Translation © 1972 Octopus Books Limited

Distributed in Australia by
Angus & Robertson (Publishers) Pty Ltd
102 Glover Street, Cremorne, Sydney

ISBN 7064 0029 1

Originally published in Italian by
Fratelli Fabbri Editore
© 1966 Fratelli Fabbri Editore, Milan

Printed in Italy by Fratelli Fabbri Editore

CONTENTS

PHIDIAS AND HIS CIRCLE

What the ancients admired most in the sculptor Phidias was his ability to represent divine majesty and the authority of the Olympian gods. In this he was considered unsurpassed, as was Polyclitus in expressing the beauty of the human form. Of all Phidias's achievements the work which, more than any other, seemed to embody those qualities was the gigantic chryselephantine (gold and ivory) statue of Zeus at Olympia, one of the seven wonders of the ancient world; it became as it were the symbol of Phidian art. The probable year of its consecration, 448 BC, was said by Pliny to have marked the highest point in the sculptor's career; and the consul Paulus Aemilius, visiting the Greek monuments after the victorious campaign in Macedonia, was so struck with awe at the sight of the statue at Olympia that he thought he was gazing upon the face of the god himself and ordered a magnificent sacrifice in his honour.

Gone now are the great statues of worship. One of the most famous was the bronze colossus of Athena Promachos, thought to have been about twenty-five feet high. It was erected on the Acropolis with money from the spoils of Marathon. The point of the goddess's spear was visible

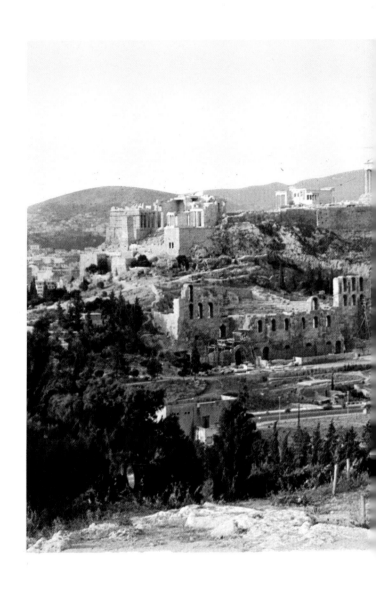

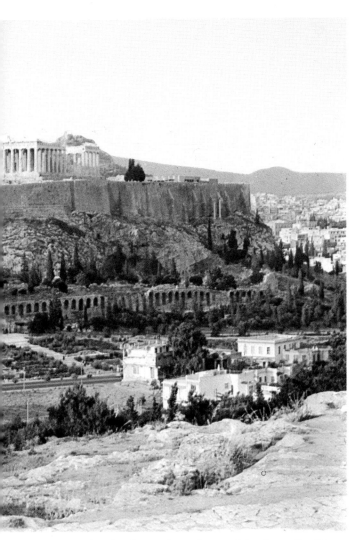

1 *Greek art : General view of the Acropolis, Athens.*

1 Greek art: General view of the Acropolis, Athens. On the Acropolis are gathered some of the most important and evocative examples of Classical Greek architecture.

2 Greek art: The Parthenon, Athens.
Phidias worked from 447 to 432 BC on the Parthenon, the most perfect expression of the spirit and civilization of ancient Greece.

3 Greek art: Dione and Aphrodite; from the east pediment of the Parthenon. London, British Museum.
The soft, fluid folds of Aphrodite's tunic, as she leans back against her mother Dione, emphasize the relaxed mood of this exquisite composition.

4 Greek art: Battle between Centaurs and Lapiths; metope of the Parthenon. London, British Museum.
The figures, concentrated in the tension of battle, stand out forcefully against the background.

5 Greek art: (Top) Heifer led to the sacrifice; from the frieze of the Parthenon. London, British Museum. (Bottom) Poseidon, Apollo and Artemis; from the frieze of the Parthenon. Athens, Acropolis Museum.
The sculptures of the Parthenon, although the work of several artists, show in their conception the imprint of the same genius.

6 Greek art: Athena; Roman copy of the original by Phidias. Athens, National Archaeological Museum.
The Roman copy can be but a pale reflection of the original.

2 *Greek art: The Parthenon, Athens.*

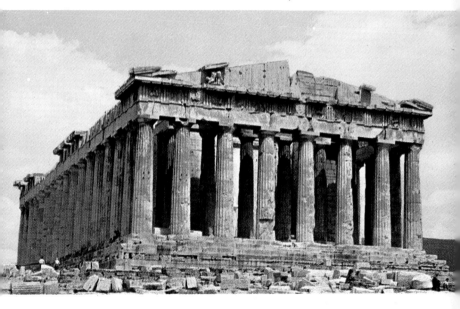

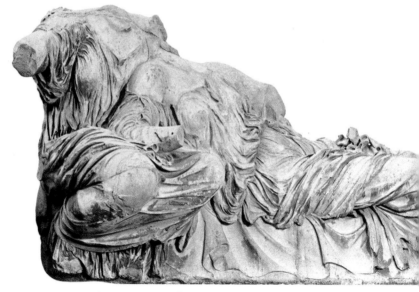

3 *Greek art : Dione and Aphrodite ; from the east pediment of
the Parthenon. London, British Museum.*

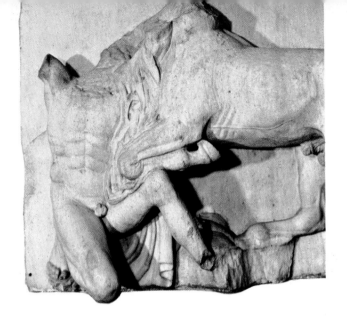

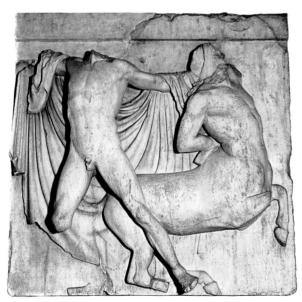

4 *Greek art : Battle between Centaurs and Lapiths ;
metope of the Parthenon. London, British Museum.*

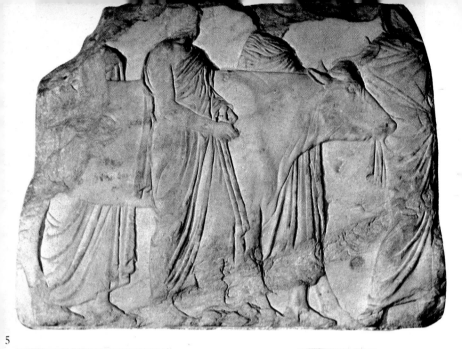

5

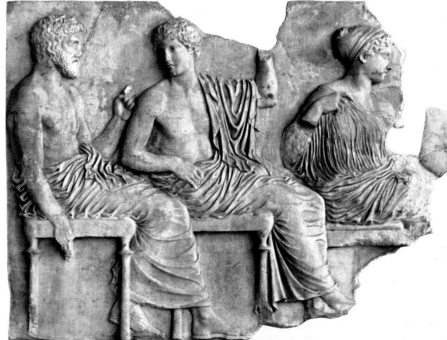

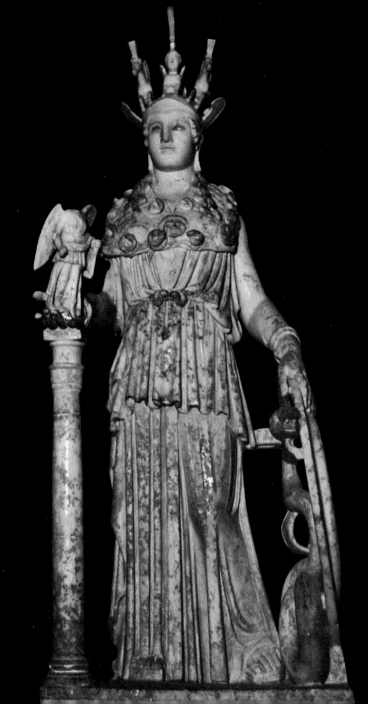

to mariners heading for Athens as soon as they had passed Cape Sounion and the statue served as a landmark for miles around. Now that all these statues are lost it is difficult to assess this aspect of Phidias's genius, so warmly extolled by ancient writers.

All that remains of Phidias is the work he did on the Parthenon, the most famous and most splendid of the temples on the Athenian Acropolis. Yet the aspect of the famous sculptor revealed by the marbles of the Parthenon is hardly one of Olympian majesty, like the chryselephantine colossi. This magnificent monument erected by Pericles embodies the ideals of his age and of a democratic and prosperous Athens which was the leader, both political and spiritual, of all the Hellenic states. As soon as the political party of Cimon and Thucydides was overthrown, Pericles turned his attention to a vast programme of public works. This is perhaps the most significant achievement of the great statesman who, though of aristocratic birth, placed himself at the head of the popular party and commanded the devotion and loyalty of every class of Athenian citizen. Pericles's opponents criticized his programme as demagogic and sacrilegious, for it was to be financed with the funds of the Panhellenic League which had been raised for the defence of Greece against the Persians. But Pericles's intentions were not misunderstood by historians. Plutarch comments as follows in his *Life of Pericles*:

'Pericles told the citizens that they were in

no way obliged to give any account of their finances to the allies, as they were fighting for them and checking the advance of the barbarians whilst the allies did not so much as contribute one horse or ship or foot-soldier, but only money: which money belonged no longer to those who gave it but to those who received it if they gave something in return. And since the city was sufficiently provided with everything it needed in case of war, the Athenians should use what means they had in undertakings which would bring the city eternal fame and provide employment for many as soon as they were started: these undertakings which needed all professions and a variety of workmanship would in effect provide work for the entire city . . . So he drew vast plans for public buildings and other works which provided employment for many categories of people and he put his plans before the citizens, so that those who remained at home might earn the benefits and have their share of the public monies no less than those who were at sea or in garrisons or at war. The materials used were stone, bronze, ivory, gold, ebony and cypress wood. Among the artisans who worked on them were carpenters, sculptors, goldsmiths, stone-masons, chisellers, copper and ivory workers, engravers, painters, dyers and all their assistants; then the men who transported the materials – merchants, mariners, pilots, carters, owners of beasts of burden, mule-drivers, rope-makers, weavers, leather-workers, diggers and miners. Finally

each profession comprised an army, as it were, an anonymous throng of labourers who were like the organs and limbs of a body and were used for many services. In this way men of every age and rank were employed. And as the works took shape, stately in size and exquisitely beautiful, the workmen all strove to outvie one another in the precision and perfection of their technique.'

Phidias was surveyor-general of the great site of the Parthenon, and in principle of the whole of Pericles's programme of public works. It is likely that the arguments which went on in Pericles's intellectual circle were free-ranging and informal, perhaps similar to those between Raphael and Bramante at the court of Pope Leo X. The works which resulted from these discussions are thus described by Plutarch:

'From the aesthetic point of view these works were even then regarded as antique; but their freshness today is remarkable. There exudes from these monuments a spirit of youth which has not been affected by time and the images are still imbued with the breath of life, as if endowed with a soul which will never grow old.'

For us today the importance of Phidias lies mainly in his interpretation and development of an austere artistic tradition and in his search for a style through which he could express, as naturally as possible, the dignity and beauty of man. This reached out beyond the rather rigid canon of Polyclitus towards what Bianchi Bandinelli described as 'a more complete mastery of

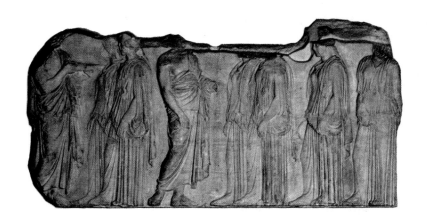

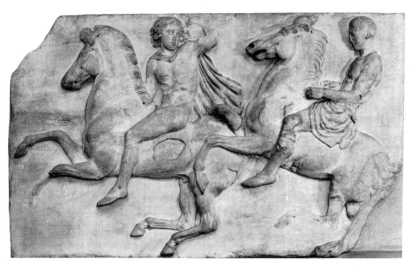

7 *Greek art : Panathenaic procession ; from the frieze of the Parthenon.
Paris, Louvre.*

19

7 Greek art: Panathenaic procession; from the frieze of the Parthenon. Paris, Louvre.
(Top) In the slowly moving procession are youths and girls bearing the usual ritual wreaths. The girls wear intricate tunics as a gift to the virgin goddess Athena.
(Bottom) These young horsemen, part of the Panathenaic procession, are among the finest works of Phidias.

8 Greek art: Dionysus; from the east pediment of the Parthenon. London, British Museum.
In the left corner of the east pediment of the Parthenon which represented the birth of Athena, sat Dionysus, the god of wine and joy, leaning against a rock.

9 Greek art: The Caryatid Porch of the Erechtheum. Athens, Acropolis.
The porch of the Erechtheum is supported by six tall statues of girls instead of the Ionic columns supporting the rest of the building. The effect is extremely graceful.

10 Greek art: The Erechtheum (fifth century BC). Athens, Acropolis.
The temple, dedicated to Athena and Poseidon, was built on the ruins of the house of Erechtheus, ancestor of the Ionians, whose name was subsequently given to it. The lack of symmetry in the building is due to the uneven surface of the terrain.

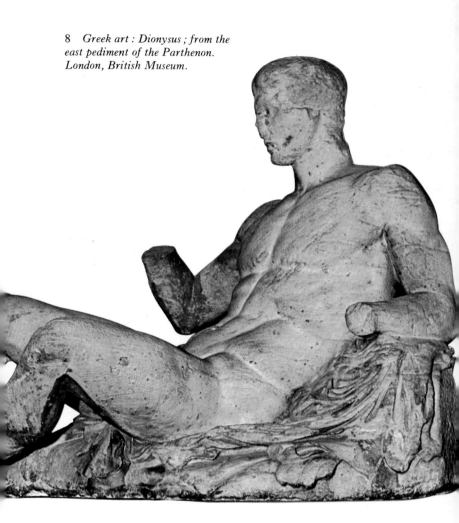

8 *Greek art : Dionysus ; from the east pediment of the Parthenon. London, British Museum.*

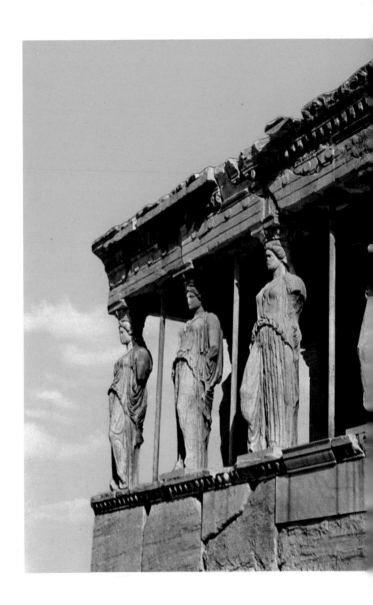

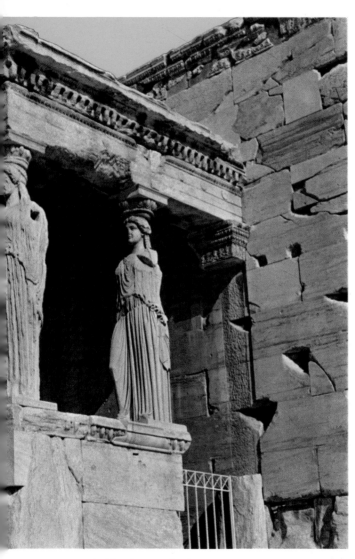

9 *Greek art : The Caryatid Porch of the Erechtheum.*
Athens, Acropolis.

10 *Greek art : The Erechtheum (fifth century BC). Athens, Acropolis.*

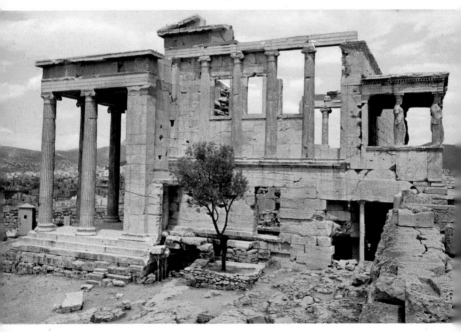

the universe' and a greater 'faithfulness to the changing aspects of reality'.

The marbles of the Parthenon must be viewed as an example of Greek humanism in which the Athens described by Plutarch could recognize its own image, rather than as a canon of absolute beauty. This was perceived by the Italian humanists, who founded their own culture – albeit a very different one – on classical art; it was also understood, in a different way, by the followers of Winckelmann who refused to condone the removal by Lord Elgin of some of the Parthenon marbles.

Phidias had been a student of Hegias and of the bronze sculptor Hageladas, and had been brought up in the austere stylistic tradition, as is evident from one of his earliest works, the statue of the poet Anacreon, which was erected on the Acropolis about 460 BC. But already in the statue of Athena Promachos (*c.* 455 BC) the drapery has changed, no longer arranged in traditionally rigid, compact folds. If the statue is the same as that described by the Byzantine historian Nicetas Acominatus, who saw it at Constantinople (where it was destroyed in 1203, during the fourth Crusade), it was, despite its huge size, extremely delicately modelled, with intricate drapery, a bare neck, 'irresistibly pleasing to gaze at', and hair which was 'a joy for the eye, not entirely covered by the helmet, but with a few loose curls'.

By 450 BC Phidias's reputation must have been well established at Athens, especially as a result of the statue of Athena Promachos, for Cimon,

wishing to erect a monument in honour of his father Miltiades, the victor of Marathon (and thereby to enhance the prestige of his own party), commissioned him to build a memorial for the sanctuary at Delphi to commemorate the victory over the Persians. In it Miltiades was depicted next to Athena and Apollo, surrounded by the heroes of the Athenian clans. Phidias may have been inspired by Polygnotus's frescoes in the Stoa Poikile which also represented Miltiades and the battle of Marathon. The art of portraiture not being established in Greece at that time, it is probable that his features were idealized; Phidias may have wanted to represent him as a symbol or prototype of a statesman.

It was probably about the year 448 that Pericles's workshop finished the huge ivory and gold statue of Zeus, although many authoritative scholars, giving credit to the traditional story of Phidias's escape from Athens after his famous trial, consider the statue to be of a later date.

Phidias was regarded by the ancients as a universal genius, master of every technique and able to treat any subject with the utmost skill and artistry. It is obvious, however, that such a colossal undertaking as the statue of Zeus could not be handled by one artist alone; so Phidias organized at Olympia a workshop (or *ergasterion*), the ruins of which have been found, together with some moulds which had been used for the gold drapery (gold obviously not being modelled by hand but melted down and set in moulds).

The workshop at Olympia was in a way a preparation for the great work-site of the

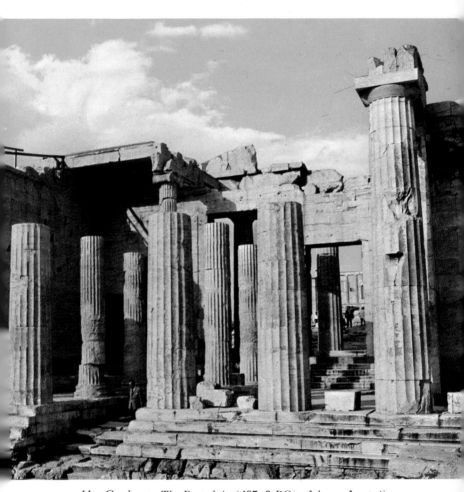

11 *Greek art: The Propylaia (437–3 BC). Athens, Acropolis.*

11 Greek art: The Propylaia (437–3 BC). Athens, Acropolis.
Pericles's plans included a triumphal gateway to the Acropolis – the Propylaia, designed by Mnesicles and built at the top of a monumental stairway leading up to the hill.

12 Greek art: Temple of Athena Nike (430–20 BC). Athens, Acropolis.
The small temple of Athena Nike on the Acropolis is an exquisite example of the Ionic style. Four slender columns stand at either end of the *cella*, or walled room; the frieze on the architrave runs right round the temple and is typical of Ionic architecture.

13 Greek art: Nike by Paeonius (end of fifth century BC). Olympia, Archaeological Museum.
The mighty figure, with her tunic flowing behind her, swoops down as if on a wind of victory.

14 Greek art: Funerary stele (end of fifth century BC). Copenhagen, Ny Carlsberg Glyptothek.
The influence of Phidias, which affected almost all contemporary sculptors, extended even to funerary stelae in which the proportions were gradually changed to allow for more powerful compositions.

15 Greek art: Back of a bronze mirror from Corinth (end of fifth century BC). London, British Museum.
The shiny bronze surface is delicately engraved with a dancing maenad and the whole area of the drawing is inlaid with a very fine sheet of silver.

16 Greek art: Aphrodite enthroned; inside of a cup by the painter of Lyandros (middle of fifth century BC). Florence, Archaeological Museum. Many renowned painters also decorated pottery and produced fine works such as the one illustrated here.

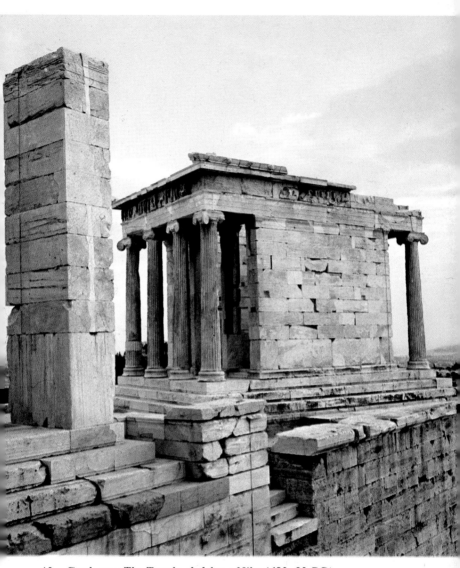

12 *Greek art : The Temple of Athena Nike (430–20 BC).*
Athens, Acropolis.

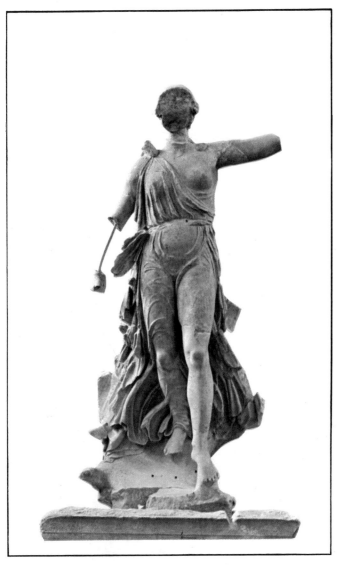

13 *Greek art : Nike by Paeonius (end of fifth century BC).*
Olympia, Archaeological Museum.

14 *Greek art : Funerary stele (end of fifth century BC).*
Copenhagen, Ny Carlsberg Glyptothek.

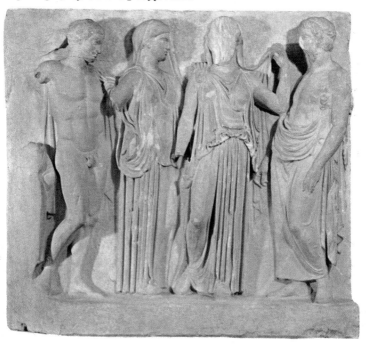

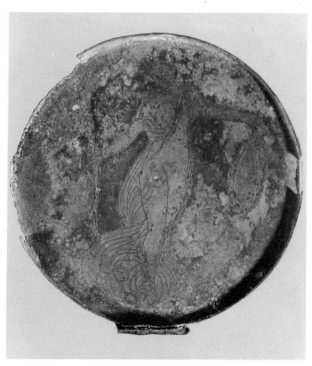

15 *Greek art : Back of a bronze mirror from Corinth (end of fifth century BC). London, British Museum.*

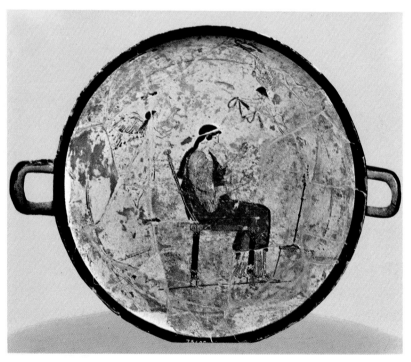

16 Greek art : Aphrodite enthroned ; inside of a cup by the painter of Lyandros (middle of fifth century BC). Florence, Archaeological Museum.

Parthenon, which was opened about 447 BC. Here the plans were made for those sculptures which became the basis of all Athenian art for the next fifty years. All the most important artists from Athens and the rest of Greece congregated on the Parthenon site; and in the shadows of the columns of the temple built by Ictinus and Callicrates there emerged a new generation of sculptors inspired by Phidias, whose artistic development was in large measure conditioned by the unique experience of working on the Parthenon.

The unifying influence on Athenian art of Phidias's ideas and directions can be seen in what remains of the decorations of the Parthenon. A few fragments amongst the ninety-two metopes of the Doric frieze, where the style is more rigid, show the difficulty that several artists, brought up in the traditional school, had in putting Phidias's precepts into practice. As far as the metopes were concerned Phidias generally indicated the design to be followed and left the execution to his assistants. He himself, however, did more work on the internal frieze which ran right round the *cella*, and which was a stylistic innovation. The frieze, representing the procession of the people of Athens in honour of their patron goddess at the time of the Panathenaic festivities symbolizes Periclean Athens, its social structure and achievements. It is a life-like scene with figures reminiscent of Polygnotus (who was the first to represent women wearing transparent drapery, the clinging 'see-through' tunics dear to Phidias himself), and is animated by a variety of

episodes – a crowd of handsome Athenian youths and beautiful maidens, the famous cavalcade of prancing horses and riders with its 'impressionistic' rendering of distance (a swiftly-moving horse or man, seen dimly or fleetingly), groups of men lagging behind, deep in conversation, calm and dignified elders, and so on. It depicts a broad variety of moods and human situations, with a wealth of detail which had never previously been attempted in Greek art. Whereas a few slightly clumsier parts in the frieze show signs of being the work of assistants, the decoration of the two pediments (the west pediment representing the mythical contest between Athena and Poseidon for the possession of Attica, and the east pediment depicting the birth of Athena) seems to be entirely the work of Phidias, as is only natural, for the pediment was considered to be both the physical and spiritual apex of the temple.

Phidias's representation of gods was not substantially different from his depictions of men, though perhaps more solemn. The countenance of the Olympian deities is more human than one would expect from the traditional image of divinity suggested by ancient sources. Perhaps this vision of divine authority was expressed more explicitly in the chryselephantine statue of Athena Parthenos, whose face and arms were made of ivory and drapery of gold. This kindly, attentive goddess of peace, worthy symbol of Periclean Athens, was in the end the cause of Phidias's downfall. The sculptor was accused of embezzling some of the gold reserved for the decoration of the statue, and of impiety for

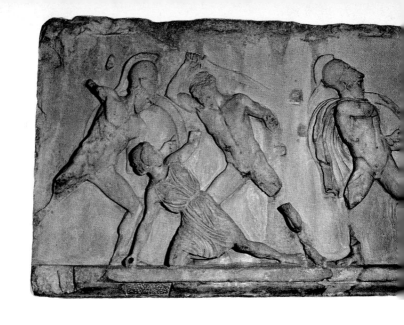

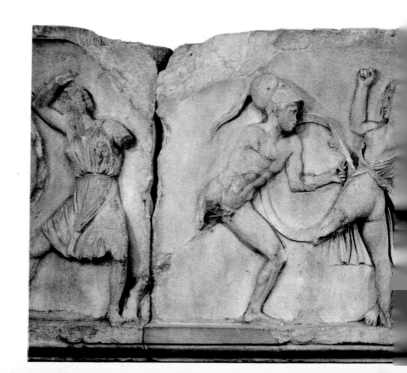

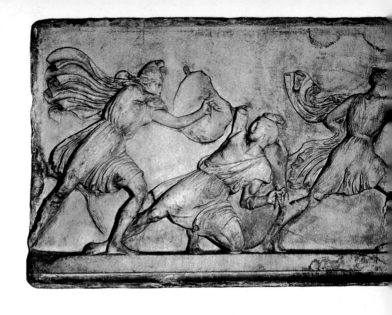

17 *Greek art : Battle between Greeks and Amazons ; detail of a frieze from the Mausoleum at Halicarnassus (**377–53 BC**). London, British Museum.*

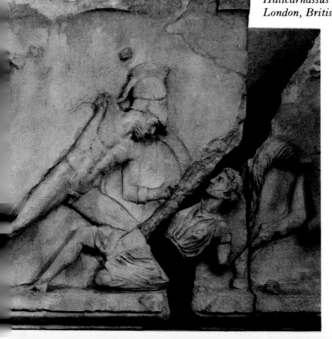

17 Greek art: Battle between Greeks and Amazons; frieze from the Mausoleum at Halicarnassus (377–53 BC). London, British Museum.
Some critics see the hallmark of Scopas in the dramatic movement of the reliefs representing the battle between the Greeks and the Amazons.

18 Greek art: The so-called Head of Ariadne by Scopas (first half of fourth century BC). Athens, National Archaeological Museum.
In the fourth century the tranquil dignity of Phidias's sculpture gives way to works of dramatic intensity, with tormented faces and eyes swollen with tears.

19 Greek art: Copy of the Diadumenos by Polyclitus. Athens, National Archaeological Museum.
The perfect proportions of the body, the severe lines and serene face express an ethical ideal in which beauty and virtue are inseparable.

20 Greek art: Marble head (beginning of fourth century BC). Paris, Louvre.
This male head, with its delicate features and thoughtful expression, heralds the dramatic sculpture characteristic of Scopas.

21 Greek art: Bronze head of Hypnos (fourth century BC). London, British Museum.
Hypnos, Sleep, the brother of Death, is shown here with his eyes half-closed, lips slightly open, and the whole face suffused with gentle drowsiness.

18 *Greek art : The so-called Head of Ariadne by Scopas (first half of fourth century BC). Athens, National Archaeological Museum.*

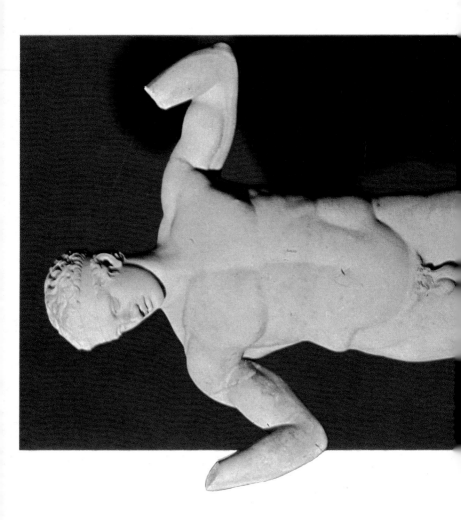

19 *Greek art : Copy of the Diadumenos by Polyclitus. Athens, National Archaeological Museum.*

41

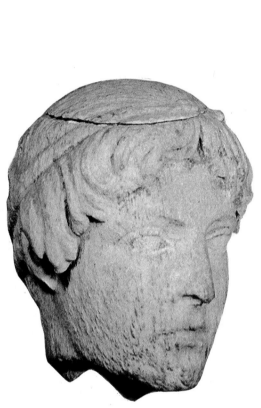

20 *Greek art : Marble head (beginning of
fourth century BC). Paris, Louvre.*

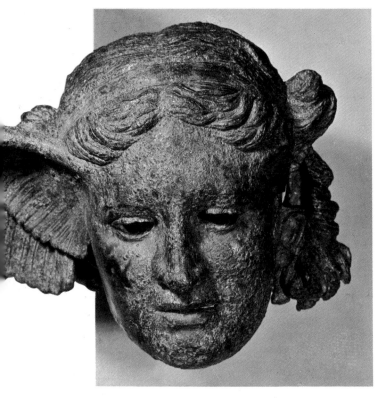

21 *Greek art : Bronze head of Hypnos (fourth century BC). London, British Museum.*

having been so bold as to represent himself next to Pericles in the Amazon battle scene on the shield. This, incidentally, seems to have been a common fate among the intellectuals at the time. Socrates, like Phidias, was accused by the conservatives of impiety, further evidence of the continued objections to the artist's newly-found social status and the claim of art to reflect men's highest moral values and express his deepest spiritual yearnings. So Phidias was tried and condemned, dying in prison. According to another story (less credible and of later origin, perhaps invented by someone who felt strongly about the indignity of seeing the famous sculptor brought to trial) he took shelter in Elis, at Olympia. The disgrace and death of the greatest artist of the age foreshadowed the impending crisis threatening the ideals and very existence of Periclean Athens.

Amongst Phidias's immediate followers was Colotes, an expert in chryselephantine technique and formerly Phidias's chief assistant on the statue of Zeus at Olympia; but his own favourite disciples were Agoracritus and Alcamenes. The former is an elusive figure, known mainly from copies of his most famous works, amongst which was the Rhamnous Nemesis. As for the better known Alcamenes, some authoritative scholars assert that several of his originals remain, notably the fine group with Procne and Itis on the Acropolis (which seems to have stepped down from the Panathenaic procession) and, above all, the caryatids on the porch of the Erechtheum. This was the temple begun by Philocles in 421

22 Greek art: Hermes and the infant Dionysus, attributed to Praxiteles (350–30 BC). Olympia, Archaeological Museum.

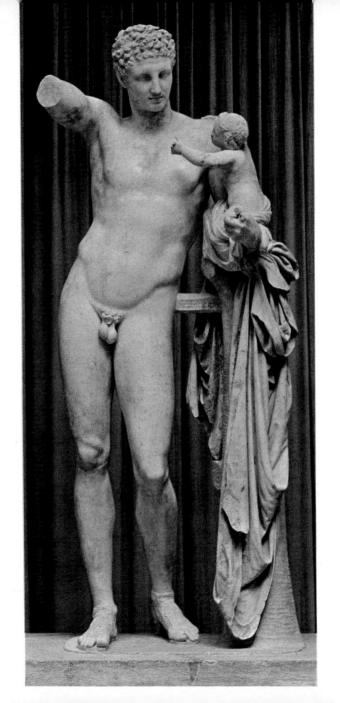

22 Greek art: Hermes and the infant Dionysus, attributed to Praxiteles (350–30 BC). Olympia, Archaeological Museum.
The attribution to Praxiteles of this statue of Hermes found in the Heraion at Olympia, is partly due to Pausanias's description of it, but not unanimously accepted by scholars.

23 Greek art: Aphrodite of Cnydos; copy of the original by Praxiteles. Olympia, Archaeological Museum.
Praxiteles's statues of divinities are characterized by a languid, subtly melancholy beauty; the sculptor's favourite medium was marble.

24 Greek art: Head of Aphrodite (fourth century BC). Boston, Museum of Fine Arts.
This wonderful head of Aphrodite, with its soft, oval face, delicate modelling and dreamy expression, belongs to the school of Praxiteles.

25 Greek art: Head of a young girl from Chios (end of the fourth century BC). Boston, Museum of Fine Arts.
This head of a young girl absorbed in a dream shows, in its soft modelling, the imprint of an artist very close to Praxiteles.

26 Greek art: Relief on the plinth of a statue from Mantineia (middle of fourth century BC). Athens, National Archaeological Museum.
The reliefs on this plinth of a statue from the temple of Asclepius constitutes, according to the majority of critics, the one and only testimony to Praxiteles's genius.

27 Greek art: Votive monuments in Corinthian style (335–4 BC). Athens.
This monument was erected by Lysicrates to commemorate a victory in a contest. Circular in shape and decorated with columns inserted in the wall, it is one of the most graceful examples of the Corinthian style.

23 *Greek art : Aphrodite of Cnydos ; copy of the original by Praxiteles. Olympia, Archaeological Museum.*

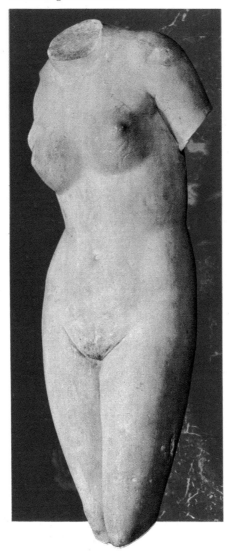

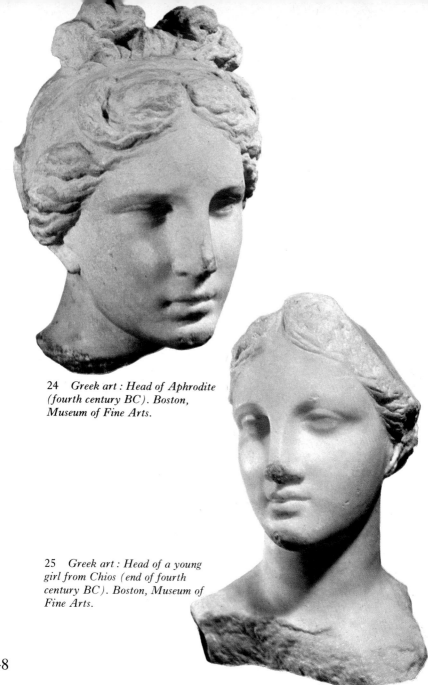

24 *Greek art : Head of Aphrodite (fourth century BC). Boston, Museum of Fine Arts.*

25 *Greek art : Head of a young girl from Chios (end of fourth century BC). Boston, Museum of Fine Arts.*

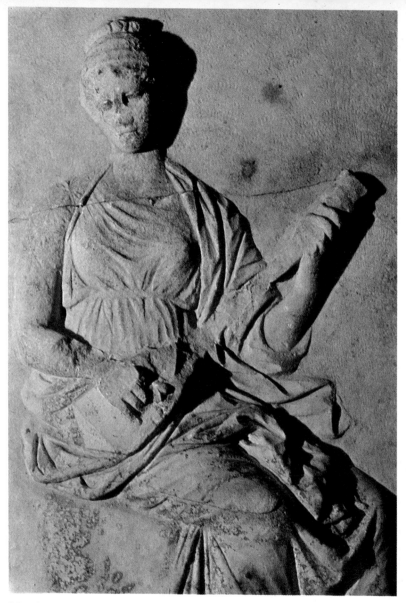

26 Greek art : Relief on the plinth of a statue from Mantineia (middle of
fourth century BC). Athens, National Archaeological Museum.

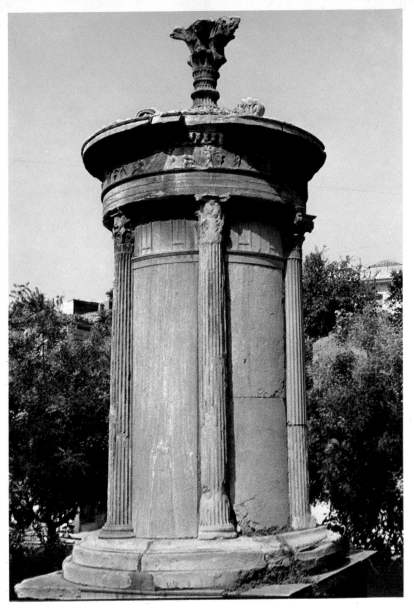

27 *Greek art : Votive monument in Corinthian style (**335–4 BC**). Athens.*

50

which, with the small Ionic temple of Athena Nike (the work of the architect Callicrates), the Parthenon and the Propylaia – the monumental gateway to the hill, built by Mnesicles from 437 to 433 – make up the rest of the buildings erected under Pericles on the Acropolis. The six caryatids of the Erechtheum, with their solemn elegance and simplicity of line, are imbued with the same spirit that is evident in the Parthenon. Not only did the art of Phidias influence his own students but also all the Greek sculptors of the second half of the fifth century BC. One of the earliest was Polyclitus whose *Diadumenos* shows the influence of Phidias's *Anadumenos* (the athlete tying his bandages before a contest), although it is more relaxed, with deeper planes and softer hair. The impact of Phidias can also be seen in numerous funerary stelae, as well as in the supple drapery of the Nikai in Callicrates's temple. The bold drapery of the Nike of Olympia, work of the Ionic sculptor Paeonius – its folds naturalistically blown by the wind, as she lands from her flight – could never have been conceived without the example of Phidias; and this in turn seems to herald the wonderful Nike of Samothrace.

The Athenian-Cretan sculptor Cresilas has a very important place in the art of the late fifth century. Among his earliest works was the bronze statue of Pericles, known through marble copies, in which the image of Pericles was interpreted according to the classical canons of portraiture which sought to convey beauty as being inseparable from virtue, rather than attempt an

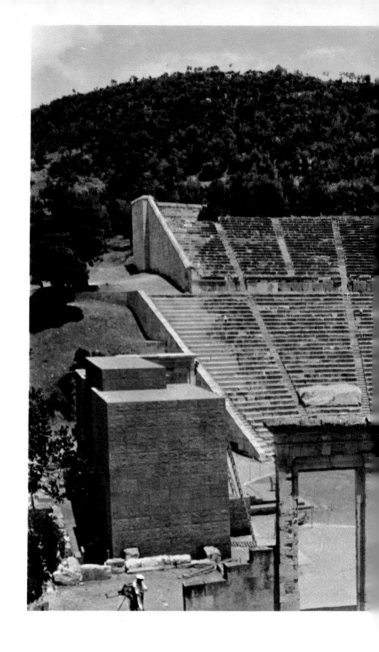

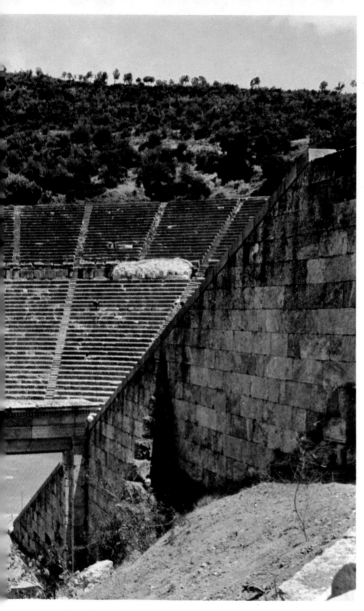

28 *Greek art : The Theatre at Epidaurus (middle of fourth century BC).*

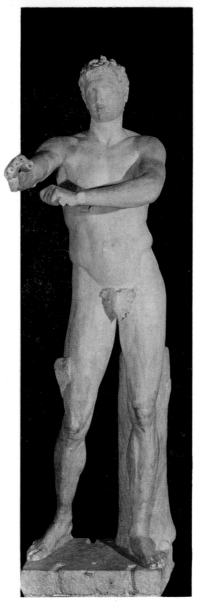

29 *Greek art : The Apoxyomenos ;*
copy of the original by Lysippus.
Rome, Vatican Museums.

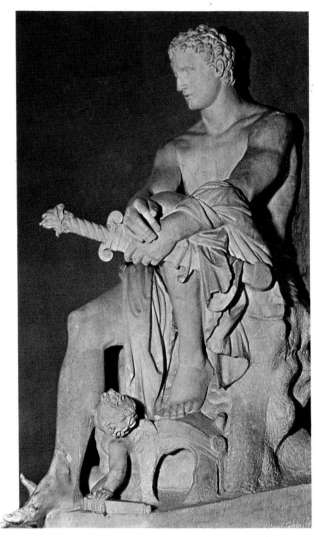

30 *Greek art: The Ludovisi Ares; copy of a bronze by
Lysippus. Rome, National Roman Museum.*

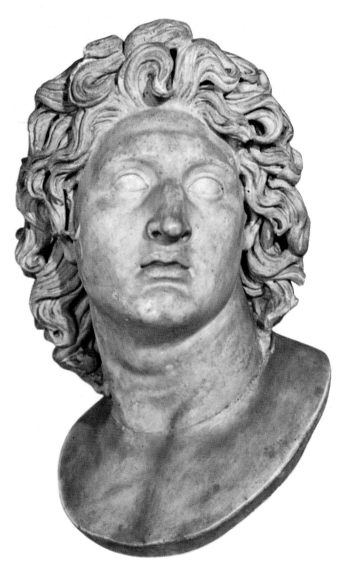

31 *Greek art : Head of Alexander the Great ; copy of the original by Lysippus. Rome, Capitoline Museums.*

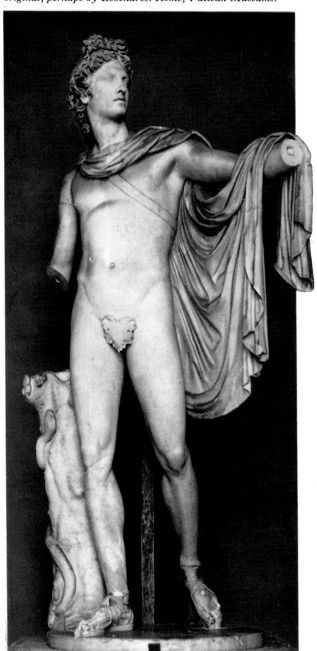

28 Greek art: The Theatre at Epidaurus (middle of the fourth century BC).
The theatre had a place of great social importance in the Greek world. In Athens magnificent productions of the tragedies of Sophocles or Aeschylus, or the comedies of Aristophanes, were given free of charge.

29 Greek art: The *Apoxyomenos*; copy of the original by Lysippus. Rome, Vatican Museums.
The statue of the *Apoxyomenos* illustrates a favourite theme in Greek sculpture – the athlete – but the rendering here has more movement and realism than in earlier models.

30 Greek art: The Ludovisi Ares; copy of a bronze by Lysippus. Rome, National Roman Museum.
The sculptures of Lysippus, with their different concept of spatial planes, herald the mobile, dramatic works of Hellenistic sculptors.

31 Greek art: Head of Alexander the Great; copy of the original by Lysippus. Rome, Capitoline Museums.
Lysippus was the favourite portrait painter of Alexander, of whom he made several likenesses. His works bear the vigorous stamp of Hellenistic portraiture.

32 Greek art: Apollo of Belvedere. Roman copy of an original, perhaps by Leochares. Rome, Vatican Museums.
The serenity of the Classical statues of gods has now been replaced by a vivid, narrative style.

33 Hellenistic art: Satyr with a wine bottle; bronze statue from Pompeii. Naples, National Archaeological Museum.
In the Hellenistic era people began to use objects of art as decoration for their houses. This statue of a playful young satyr, for instance, used to adorn the centre of a private swimming-pool in Pompeii.

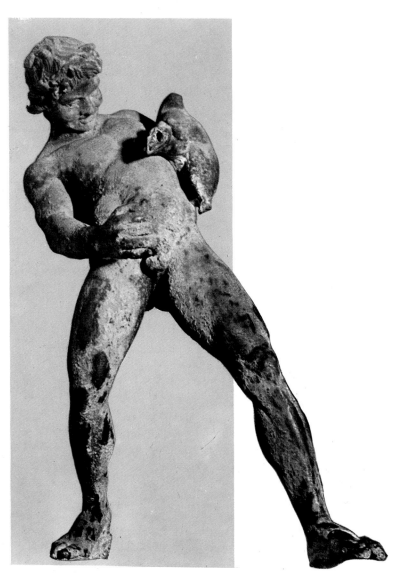

33 *Hellenistic art : Satyr with a wine bottle ; bronze statue from Pompeii.*
Naples, National Archaeological Museum.

expressive, individualistic likeness. The large, elongated helmet may be a reference to the traditional story that Pericles's head was misshapen, elongated and asymmetrical. 'The reason', says Plutarch, 'why Pericles is always represented wearing a helmet was that the artists did not want to offend him.' The head of Pericles was in fact, a favourite topic with writers of comedy. Theleclides says that when Pericles, preoccupied by some political problem, sat apart, lost in thought, 'there arose from his head/large enough to accommodate eleven beds/ a mighty rumble!'

The importance of Cresilas, however, lies above all in the psychological overtone of his works – something new in classical art. This is seen, for example, in the poignancy and pathos of his wounded Amazon, one of four made for a competition for the decoration of the sanctuary at Ephesus, described by Pliny, in which the other contenders were Phidias, Phradmon and Polyclitus (the eventual winner). Cresilas represents a fundamental landmark in the transition from the absolute to the incidental, the portrayal of a brief moment, not in a mythical or heroic existence, but in a human, private life. The movement of the Amazon as she turns to look at her wound prefigures the episodic subject-matter so dear to the fourth century and Hellenistic art.

In the second half of the fifth century painting was dominated by the figures of Zeuxis and Parrhasius who were extolled by ancient historians. Zeuxis appears as a youth in Plato's

Protagoras which is supposed to take place around 432 BC. The anecdotes reported by ancient writers about Zeuxis's works are well-known, such as the one about the birds pecking at his painting of a bunch of grapes. It was fashionable at one time to extol art in which reality was exaggerated, but Zeuxis's painting was evidently very naturalistic and his ideal of natural beauty consistent with the technique he used in his painting of Homer's Helen. It is said that he chose the finest features of five Athenian girls and combined them in this idealized portrait. Such a method did not have the anti-naturalistic overtone attributed to it by the seventeenth-century classical theorists who searched for ideal beauty. Selective and harmonious beauty was also Phidias's ideal. Greek art in the fifth century was not yet familiar with true portrait painting and the representation of everyday subjects, but in contrast with both the archaic period and austere tradition, beauty as depicted by Phidias and Zeuxis does represent in some ways an approximation to reality; far from being idealized, it is natural and vibrant.

The other great fifth-century painter, Parrhasius, was famous for the elegance of his line, and his style may have been similar to that of the Nikai in the temple of Athena Nike. Parrhasius used to paint dressed in a garment of purple and gold, and was described as a 'pupil of the Muses', no more as a 'mere mechanic'. It may be imagined how impious this new conception of the artist was in the eyes of the Athenian conservatives.

THE FOURTH CENTURY

The death of Pericles, and the Peloponnesian War (431–404 BC) heralded the collapse of Athenian power. Phidias's golden age and its intellectual and artistic ideals were buried with the debris of Athens in the chaos and confusion which now prevailed throughout the Hellenic world. The fifth-century artistic ideal as expressed in Phidias's Panathenaic frieze, with its grave and serene beauty, its Olympian nobility and majesty, vanished completely in the upheaval of war. Art now struck out on a new path, concentrating on the problems and feelings of individuals.

In Athens, while Cephisodotus the Elder was still influenced by the Phidian image – as in his statue of Peace and Wealth – his son, Praxiteles, developed in an entirely different direction. His statues of gods are always of young people performing ordinary actions in an everyday setting; thus the Apollo Saurochtonus is striking at a lizard, the Hermes at Olympia plays with the infant Dionysus, the Cnydian Aphrodite is preparing for her bath (here, for the first time, a female divinity is represented in the nude; according to legend the model for the statue was the beautiful courtesan Phryne). A totally new artistic ideal is expressed in the tender, melancholy beauty of these statues, in the fleeting moment of carefree pleasure, caught as if by chance. The gracefulness of youth, sometimes unripe, sometimes in full bloom, shy and lost in thought, is depicted with delicacy,

34 *Hellenistic art : The Knife-grinder ; Roman copy. Florence, Uffizi.*

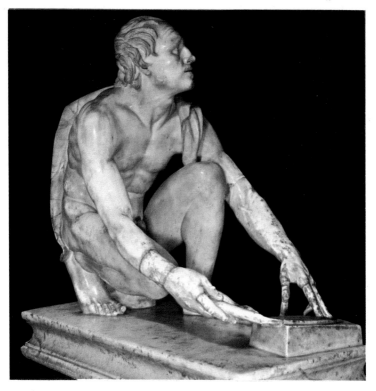

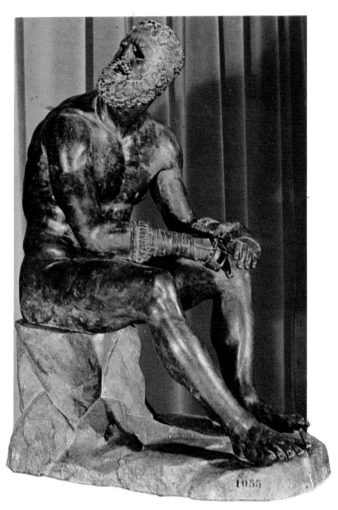

35 *Hellenistic art : The Boxer. Rome, National Roman
Museum.*

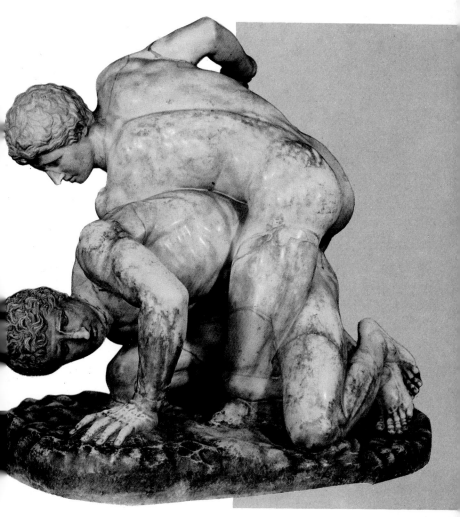

36 *Hellenistic art : The Wrestlers. Florence, Uffizi.*

34 Hellenistic art: The Knife-grinder; Roman copy. Florence, Uffizi.
This statue is one of the finest examples of the striking narrative appeal of the best of Hellenistic art.

35 Hellenistic art: The Boxer. Rome, National Roman Museum.
The detailed treatment of the face and body of this bronze statue reveals a high degree of anatomical observation and psychological insight.

36 Hellenistic art: The Wrestlers. Florence, Uffizi.
The greatest ambition of the Hellenistic sculptor was to represent the human body from every possible angle and to illustrate the greatest variety of movement.

37 Hellenistic art: Young Girl from Anzio. Rome, National Roman Museum.
Found at Anzio in 1878, this may have been a votive statue; it is certainly one of the most delicate Hellenistic works inspired by Praxiteles.

38 Hellenistic art: The Medici Venus (left); Roman copy. Florence, Uffizi. Venus of Cyrene (right). Rome, National Roman Museum.
Praxiteles's Cnydian Aphrodite inspired a series of Hellenistic versions of the goddess, all displaying a sensual quality which is foreign to Praxitelean art.

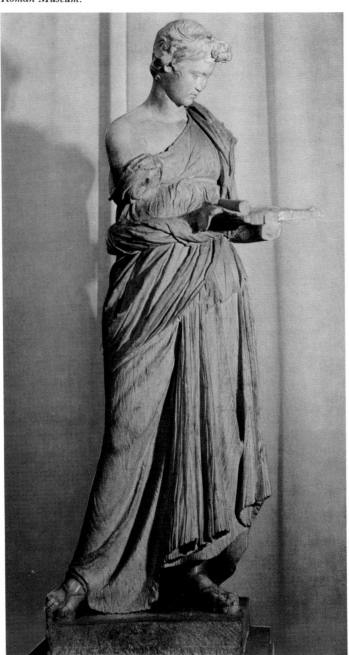

38 *Hellenistic art : The Medici Venus (left) ; Roman copy. Florence, Uffizi. Venus of Cyrene (right).*
Rome, National Roman Museum.

as if the sculptor were afraid of disturbing its mood. Praxiteles was always much admired for his soft, sensitive modelling, rendered even more vibrant by the addition of colour; the ancients described his work as 'moist', and the luxuriant hair of his statues was said to give under the pressure of one's fingers.

In contrast with Praxiteles's gentle sensuality is the vigorous and passionate art of the other great fourth-century sculptor, Scopas of Paros. The restrained sorrow of Cresilas's statues is more explicit in Scopas's war scenes and in the restless intensity of his statues. Fortunately several of Scopas's works have survived intact and all bear the stamp of his powerful modelling. The metopes and pediments of the temple of Athena Alea at Tegea can be dated 350–40. From there came the most famous piece by Scopas, the head of a warrior which, 'with its square and massive framework, its mobile, vivid modelling . . . deep-set eyes, half-opened mouth, and pathetic, upward-turned face' (Becatti), can be considered the acme of the sculptor's art. Scopas's work can also be seen in the east pediment of the Mausoleum at Halicarnassus, the monumental tomb which the widow of Mausolus, satrap of Caria, erected in memory of her husband. Apart from Scopas, the artists who contributed to the Mausoleum (the greatest architectural achievement of the fourth century and one of the seven wonders of the world) were the Athenians Bryaxis and Leochares, and Timotheus of Epidaurus. It is not easy to distinguish the fragments by Scopas's hand

amongst the reliefs which remain from the pediment of the Mausoleum, but several critics see his imprint in the dramatic movement and free narrative of the scenes representing the fight between the Greeks and the Amazons.

After Scopas the most famous artist amongst those who worked on the Mausoleum was certainly Leochares to whom scholars attribute the Apollo of Belvedere, one of the most celebrated statues of antiquity, with its luxuriant hair, proud stance, magnificent body and wide-flung arm. Winckelmann saw in the Apollo of Belvedere one of the most sublime expressions of ideal beauty: 'eternal spring . . . quivering with delicate grace on superbly-structured limbs . . . In the Apollo, an image of the most sublime divinity, the musculature is subtle, hardly visible, like pure glass blown in waves, guessed at rather than seen . . . His stance is so light that he barely touches the ground with his foot.'

The youngest amongst this impressive group of fourth-century sculptors was Lysippus, born in Sicyon in the Peloponnese. He was strongly influenced by his fellow-countryman Polyclitus and, like him, attempted to establish a canon – an impressionistic ideal which represented men as they appeared to be. Where Polyclitus rationalized, Lysippus chose to catch the fugitive moment; and in place of the balanced rhythm of Polyclitus's standing figures, he depicted athletes in complex attitudes and with a variety of gestures.

The most characteristic work by Lysippus is

perhaps the *Apoxyomenos*, showing an athlete drying himself after a contest, his body slender and tall, the head quite small. The rhythm is vigorous, the figure lively and well-proportioned. The favourite sculptor of Alexander the Great, Lysippus invented a type of portrait which combined idealized and individual features. So too did another famous portraitist of the fourth century, Silanion, who made a portrait of Plato about 350 BC.

The new direction in art also affected contemporary architecture. Monuments were built in accordance with an ideal of delicate harmony – no hard lines or bold innovations, but gentle proportions and fine decoration. There was a preference for circular planning, as in the Athenian monuments of Lysicrates and the capitals of Corinthian style. Several of the most famous Greek theatres belong to the fourth century.

After the death of Alexander the Great (323 BC), a radical change affected the whole gamut of Greek art as it probed eastward to permeate the empire created by Alexander. The Macedonian armies carried Hellenic culture into far-flung regions and it was this contact with new civilizations that brought about the artistic period known as Hellenistic.

HELLENISTIC ART

The term 'Hellenistic' refers to a 300-year period in Greek art which flourished in the countries conquered by the Macedonians, from the death

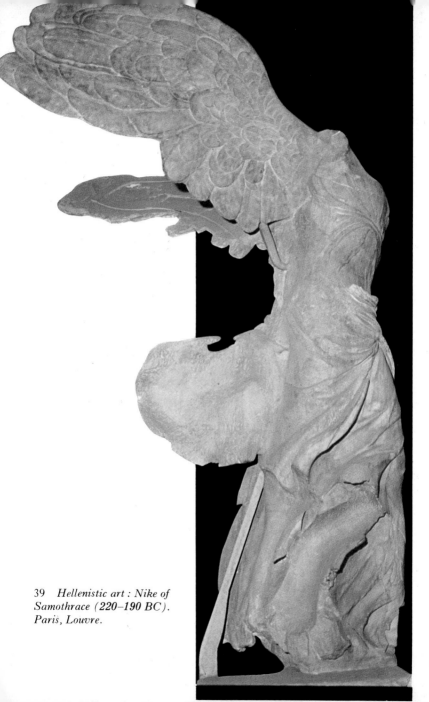

39 *Hellenistic art : Nike of Samothrace (220–190 BC). Paris, Louvre.*

39 Hellenistic art: Nike of Samothrace (220–190 BC).
Paris, Louvre.
The statue is believed to be the work of the school of
Rhodes mainly because it is made of Rhodian marble.

40–41 Hellenistic art: Temple of Bacchus, Baalbek
(second century AD). Temple of Olympian Zeus, Athens
(second century BC).
Two examples of the grandiose style of many Hellenistic
buildings.

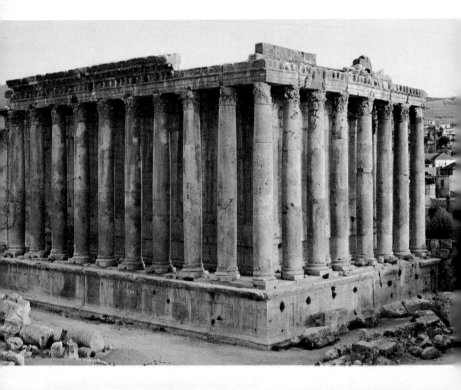

42 Hellenistic art: Venus de Milo (second century BC).
Paris, Louvre.
This statue of Aphrodite in Parian marble has become
deservedly famous as the prototype of female Greek
beauty.

43 Hellenistic art: The Callypigian Venus (first century
BC). Naples, National Archaeological Museum.
Aphrodite, about to enter the water, turns to look at her
reflection in a typically feminine gesture of satisfaction.

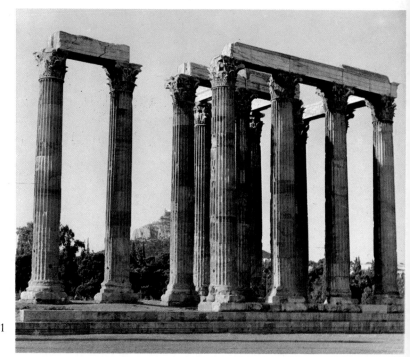

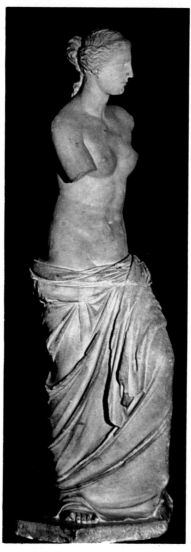

43 *Hellenistic art : The Callypigian Venus (first century BC). Naples, National Archaeological Museum.*

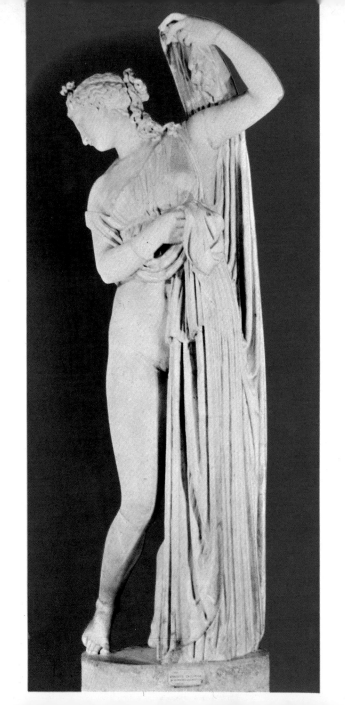

of Alexander in 323 BC to the final conquest of the Hellenized world by the Romans, principal heirs of Greek culture, culminating in 30 BC with the battle of Actium in which Octavian (later the emperor Augustus) defeated Mark Anthony and the Egyptians.

Winckelmann and the neo-Classicists considered the Hellenistic era to have been a period of decadence; but it is, on the contrary, an important period for the history of art, a time when new problems were discussed and new solutions found, which gave it an extraordinary force of expansion and penetration, exemplified by no other culture in the ancient world.

Greek culture found its way into Asia and Africa, and it was in these new lands, during the rule of the Diadochi (Alexander's successors) that it really developed, while Greece itself lagged behind, at least as far as figurative art was concerned. In Athens the great artistic achievements of the past were still held up as models. The interpretation was of course more up-to-date, but the ideas were still those of Phidias and the sculptors of the fourth century. A tradition was established and there were families of artists who handed down their profession from father to son for generations. These were the first of a long series of workshops which, in the second century BC, came to specialize in copies (somewhat cold and academic) of fifth- and fourth-century originals, executed to satisfy the unceasing demands of Roman clients. Side by side with these neo-Attic workshops was another movement, even more reactionary and ana-

chronistic, which sought inspiration from archaic sources (especially Ionic) and copied them.

The city of Tanagra, in Boeotia, on the other hand, was the birthplace of an unusual type of graceful polychrome terracotta statuette, examples of which have come to light in cemeteries throughout the Hellenistic world. These were widely exported, fulfilling a need for small, decorative objects, characteristic of an age in which art was not only meant for public but also for personal enjoyment. This is the period in which private collections first appeared, no longer limited to minor, utilitarian objects, but including paintings and statues. The development of minor arts was notable in Hellenistic times (in the making of cameos, for example, the use of *pietre dure* went back to the great Asiatic tradition of gem-cutting). The tiny Tanagra statuettes, as delicate as eighteenth-century French *biscuit* ware, must have been especially highly priced and esteemed.

The Greek islands – Rhodes, Cos, Milos – were more progressive. Nobody who has seen it could ever forget the wonderful Nike or Victory of Samothrace, the work of an unknown sculptor, her mighty wings flapping as she stands on the prow of her ship, the folds of her tunic still rippling in the wind. The Victory of Samothrace represents one of the peaks of Hellenistic art in its impression of movement and its treatment of the female form. Also from Rhodes is the Laocoön group, a later and more complex work (first century BC); it was much admired in antiquity (and in the sixteenth century when it

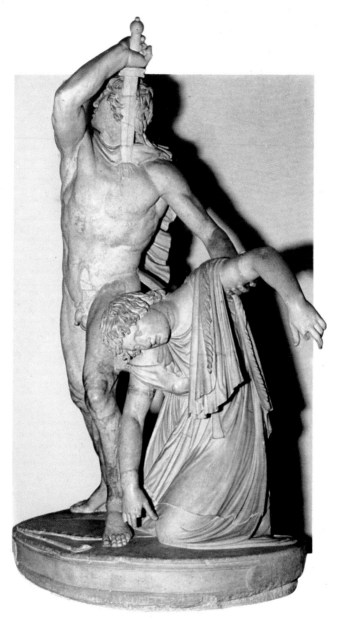

44 *Hellenistic art : Gaul killing himself ; copy of a Hellenistic bronze. Rome, National Roman Museum.*

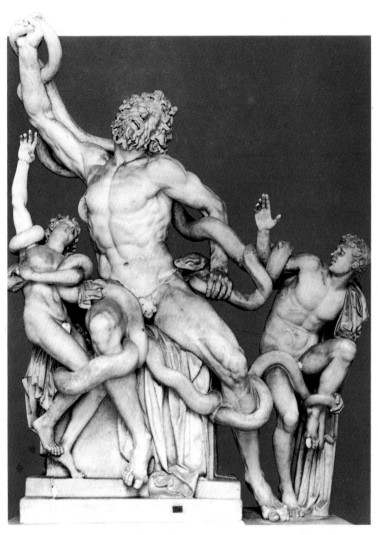

45 *Hellenistic art : Laocoön (second century BC). Rome, Vatican Museums.*

44 Hellenistic art: Gaul killing himself; copy of a Hellenistic bronze. Rome, National Roman Museum.
The realistic skill of this sculpture of a Gaul committing suicide after killing his wife shows the maturity of style reached by the Pergamon school.

45 Hellenistic art: Laocoön (second century BC). Rome, Vatican Museums.
Laocoön and his sons try in vain to free themselves from the serpents' coils. The dramatic composition of the group is animated by a powerful plastic sense.

46 Hellenistic art: Gold ring with portrait seal. Naples, National Archaeological Museum.
The Hellenistic taste for portraiture extended even to jewellery where, for example, a portrait could be made into a seal and worn as a ring.

47 Hellenistic art: The Farnese Bull; Roman copy of the original by Apollonius and Tauriscus, from the Baths of Caracalla. Naples, National Archaeological Museum.
A violent and dramatic narrative animates this copy of a bronze group representing the torture of Dirce who was condemned to be dragged by a bull across the rocky slopes of Mount Cithaeron.

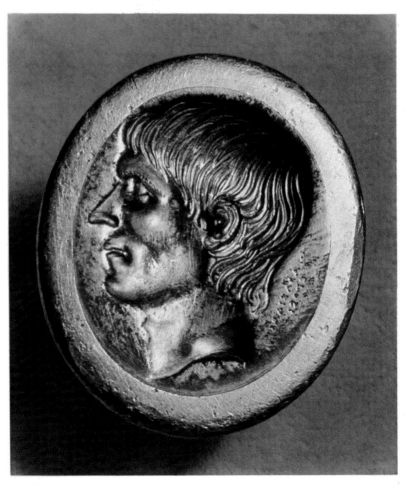

46 *Hellenistic art : Gold ring with portrait seal. Naples, National Archaeological Museum.*

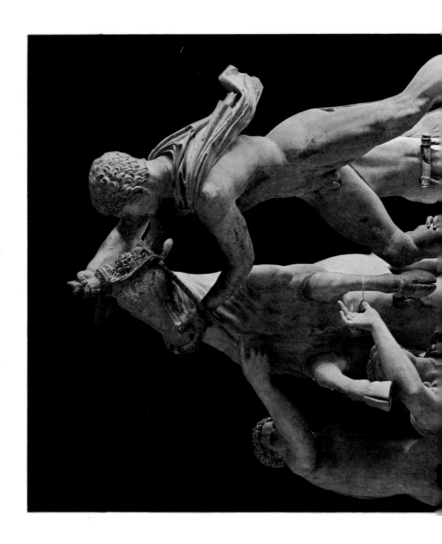

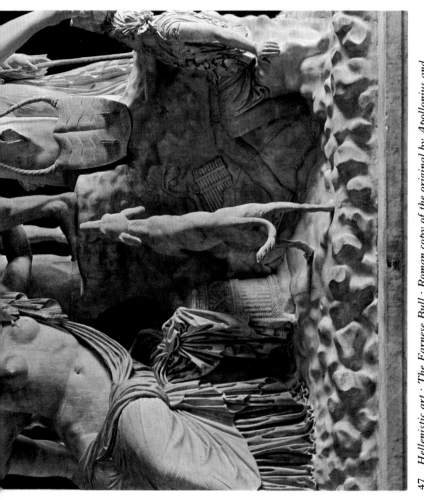

47 Hellenistic art : The Farnese Bull ; Roman copy of the original by Apollonius and Tauriscus, from the Baths of Caracalla. Naples, National Archaeological Museum.

was rediscovered) and was placed in Titus's palace in Rome. The Laocoön, which bears the signatures of the sculptors Hagesandrus, Athanadorus and Polydorus, has something of the pathetic grandeur of the so-called Baroque sculptures of the Pergamon altar of Zeus (built a century and a half earlier), but the interpretation of the Laocoön is almost academic. Its one-dimensional presentation, the analytic study of the nudes, the exaggerated naturalism which ultimately has rather a chilling effect, put it in a different category altogether from the great statues of the Pergamon altar. Already there is evidence, in Hellenistic art, of a tentative return to the classical order. It is probably this which makes the undoubtedly fine head of Laocoön much colder than those of Enceladus or Clitius from the Pergamon altar.

Equally famous is the so-called Venus de Milo which, together with the statue of the young girl from Anzio, shows another characteristic of Hellenistic art – the renewal of Praxitelean forms and subjects. These were particularly favoured by naturalistic artists for their portrayal of a brief, intimate moment in which gods were stripped of their classical tunics and represented in familiar, human attitudes. In this celebrated statue Aphrodite is depicted in the act of stopping Eros from shooting too many arrows.

The great centres of the Hellenistic age were Alexandria, Pergamon and, to a lesser extent, Antioch. Pergamon was the spiritual centre of Asia Minor and the capital of the state founded in 263 BC by the satrap Eumenes, who had

rebelled against the Seleucid dynasty of Syria. Pergamon was particularly important as it considered itself to be the bulwark of Greek civilization against the barbarian hordes, taking as its model the heroic period of the Greek struggle against the Persians. This is evident from the numerous memorials built by the Attalids to celebrate Pergamene victories over the Galatians and the Persians.

The art of the Attalid period is characterized by a grandiose, Homeric style, described by scholars as 'Pergamene Baroque'. The memorials and the superb gigantomachy frieze of the altar erected by Eumenes II (from about 181 BC) in honour of Zeus and Athena show evidence of a return to the solemnity of classical art, especially that of Phidias, and to the dramatic tone of Scopas. But here the compact, classical style is enlivened by a vigorous narrative. The powerful figures are deep in shadow and the mythical battle unfolds as if in the midst of a hurricane. 'And to intensify the effect, the shallow relief gives way to a high relief with figures almost in the round, propelled by their fight to the very steps of the altar as if unconscious of its sanctity.' (Gombrich).

The most typical centre of Hellenistic culture was perhaps Alexandria, capital of the Ptolemies. It was also a scientific capital and boasted one of the greatest libraries in the ancient world. Some of the most progressive aspects of Hellenistic art were developed in Alexandria – notably an intense realism which does not neglect the ugly (even the grotesque) or the

49 *Italic art : Bell-shaped crater of upper-Adriatic style, from Spina (fourth century BC). Ferrara, National Archaeological Museum.*

48 Greek art: Red-figured vase (detail) from Spina, attributed to the Master of the Berlin Amphora (*c.* 490 BC). Ferrara, National Archaeological Museum.
The Etruscan city of Spina in central northern Italy was a link between the Hellenistic and Italic worlds. Between the sixth and third centuries BC it was the seat of a flourishing community of Greek merchants who imported many Greek products, such as the one illustrated here.

49 Italic art: Bell-shaped crater of upper-Adriatic type, from Spina (fourth century BC). Ferrara, National Archaeological Museum.
Many examples of local ware were found in Spina, such as this bell-shaped crater. The so-called upper-Adriatic pottery is particularly characteristic of the region.

50 Greco-Italic art: Fragment of relief from southern Italy (fifth century BC). Copenhagen, Ny Carlsberg Glyptothek.
The delicate relief on this fragment of a stele is an example of the poetic style of some of the artists in the southern provinces.

51 Greco-Italic art: Bronze mirror support from a city in Magna Graecia (*c.* 500 BC). London, British Museum.
The majority of the bronzes fashioned in the colonies of Magna Graecia and Sicily were objects of applied art whose function it was to complete and adorn other objects. Mirror supports are particularly numerous.

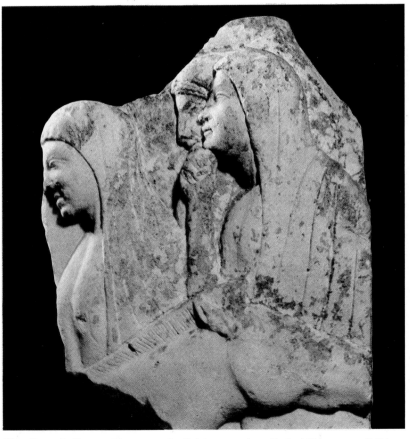

50 *Greco-Italic art : Fragment of relief from southern Italy (fifth century BC).*
Copenhagen, Ny Carlsberg Glyptothek.

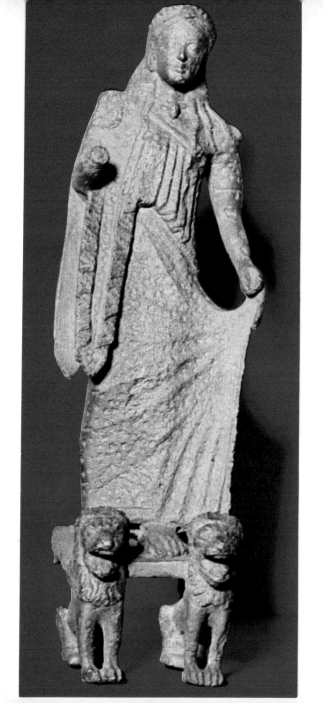

humble, as in the pathetic statuettes of little Nubian negroes, in the Mahdia bronzes, and in the bucolic landscapes with rocks and trees (hitherto unknown in sculpture) which adorn Arcadian or mythological scenes.

Alexandria was also an important centre for painting (Ptolemy III owned a vast collection of pictures) and it was in Egypt that a type of painting was developed which we would today call 'impressionistic', and which was to become extremely important in Roman painting from the golden age of Pompeii to the time of the Catacombs.

Far from being a period of decadence, therefore, the Hellenistic era produced the most 'modern' of all forms of ancient art – modern in the sense that it is nearest to our own culture and to some of today's artistic problems. Phidias and his fifth-century contemporaries were the main sources of inspiration for sixteenth- and seventeenth-century classicism, from Raphael to Domenichino. Even though we can appreciate their genius, both Phidias and Raphael express the glories of a vanished world. It is not by chance that Caravaggio was influenced in one of his works by the Drunken Old Woman (or rather the Roman copy of it) by Myron of Thebes who was active in the second century; and in more recent times the subject of the young boy removing a thorn from his foot has proved popular. Certainly we are closer in spirit to the realistic, everyday aspect of Hellenistic art than to the heroic concept of man held by the artists of Phidias's age.

51 *Greco-Italic art: Bronze mirror support from a city in Magna Graecia (c. 500 BC). London, British Museum.*

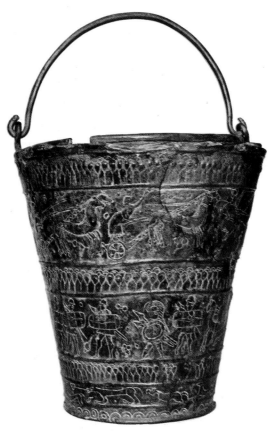

52 Italic art : Bronze situla from the Arnoaldi
Cemetery, Bologna. Bologna, Civic Museum.

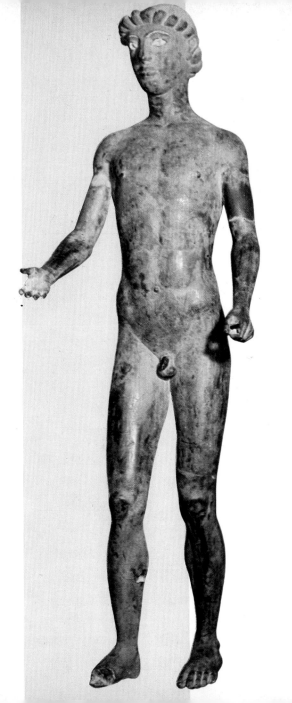

95

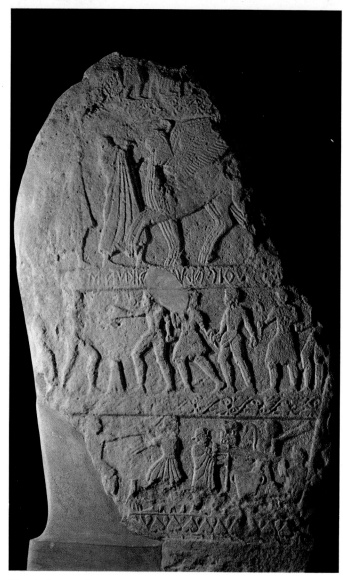

54 *Italic art : Funerary stele from Felsina (fifth century BC).*
Bologna, Civic Museum.

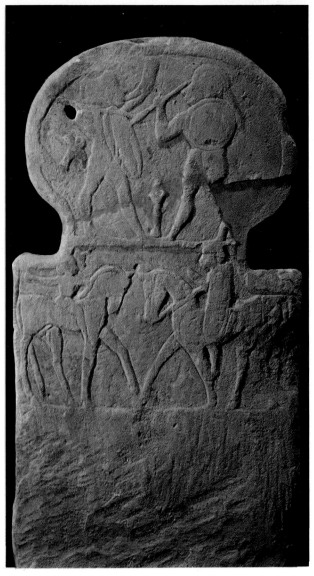

55 *Italic art : Funerary stele from Felsina (fifth century BC).*
Bologna, Civic Museum.

52 Italic art: Bronze situla from the Arnoaldi Cemetery, Bologna. Civic Museum.
This situla is an interesting example of the oriental taste as interpreted by a northern artist.

53 Greco-Italic art: Bronze Apollo from Selinunte (*c.* 460 BC). Castelvetrano, Town Hall.
This is the only known large bronze object from the city of Selinunte. It was obviously derived from Attic models although a certain rigidity in the limbs reveals its essentially provincial character.

54–55 Italic art: Funerary stelae from Felsina (fifth century BC). Bologna, Civic Museum.
Characteristic of the Etruscan city of Felsina (modern Bologna) were the funerary stelae in carved sandstone which, from the end of the sixth century, were placed on the tombs of wealthy citizens.

56 Italic art: Terracotta ossuary (Villanovan culture). Bologna, Civic Museum.
This terracotta cinerary urn was found in a little well dug in the ground and was protected by stone slabs.

57 Italic art: Bronze belt from the Benacci Cemetery, Bologna (Villanovan culture). Bologna, Civic Museum.
On this belt the use of a geometric style turns into elegant arabesques a subject which was originally figurative – the voyage of the sun drawn by swans.

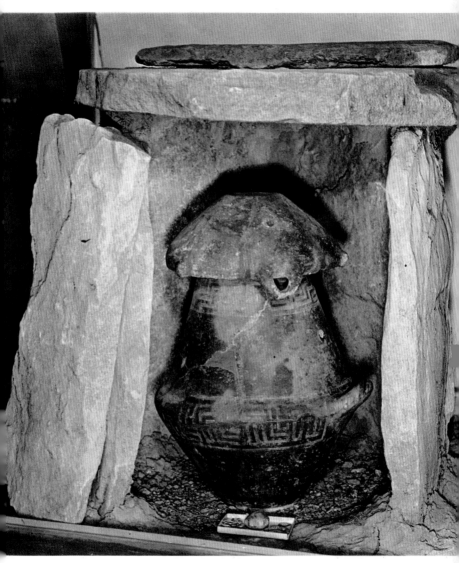

56 *Italic art : Terracotta ossuary (Villanovan culture). Bologna, Civic Museum.*

57 *Italic art : Bronze belt from the Benacci Cemetery, Bologna (Villanovan culture). Bologna, Civic Museum.*

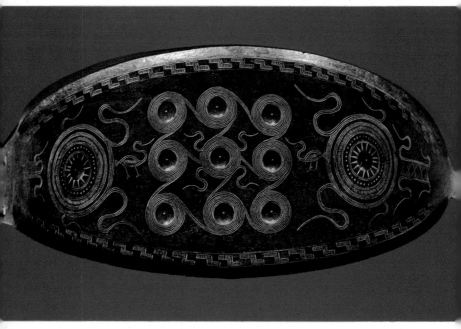

ITALIC ART

While it is easy to trace the development of Greek culture from the Bronze Age to the height of the Classical period, the same period in Italy is extremely confused, mainly because of the different origins of the peoples who lived there at that time. Scholars are still disputing the different forms of culture in Italy from the Iron Age onwards, among which can be singled out the civilization of the mysterious Etruscan people.

The transition from the Bronze Age to the Iron Age in Italy was very gradual, and seems to have come about through the progressive contact of local peoples with Aegean civilization. Even though Iron Age culture did not occur simultaneously in every region of Italy, it can be said generally to correspond to the so-called Geometric period of ancient Greek civilization, about the ninth century BC. Already at that stage it is possible to distinguish five main Italic peoples. The Latin-Siculi inhabited the Tyrrhenian coasts and Sicily. The Umbro-Sabellians lived on the opposite side of Italy. The Villanovans derived their name from the settlement of Villanova, near Bologna, one of the main seats of their civilization. The Ligurians, subdivided into various tribes, created the so-called Golasecca culture in the regions known today as Lombardy, Liguria and Piedmont; and finally the Atestines, named after the city of Ateste (the modern Este), lived in the Veneto.

Geographical confines between one group and

another were not rigid and continual contact encouraged the exchange of ideas and led to a complex cultural development. Some of these peoples, the Veneti, for example, were certainly of Indo-European origin and it is not known exactly when they settled in Italy. Others are called pre-Indo-European because they were already established in the area when the Indo-Europeans arrived. Yet others are of unknown origin, such as the Etruscans, who originally settled in northern Latium, Umbria and southern Tuscany and later colonized the Po valley and Campania.

There are certain links between the peoples of the north-west, such as their common custom of cremating the dead, whereas the tribes of the central and southern regions observed burial rites in the manner of most Indo-European peoples. Although these races lacked a genuine artistic sense, there was, nevertheless, a flourishing tradition of craftsmanship especially in pottery and metalwork. The best examples are from tombs yielding vast funerary treasures of earthenware, arms, instruments and items of personal adornment. The pottery objects, although restricted to certain fundamental types, show quite a large variety of decoration – spirals in relief, bosses contoured with dotting or enclosed in circles, concentric furrows and ribbon-shaped handles. The shapes differ slightly according to regions: the lidded ossuary, for instance, can only be found in the north-western part of the peninsula where the dead were cremated from the end of the Bronze Age.

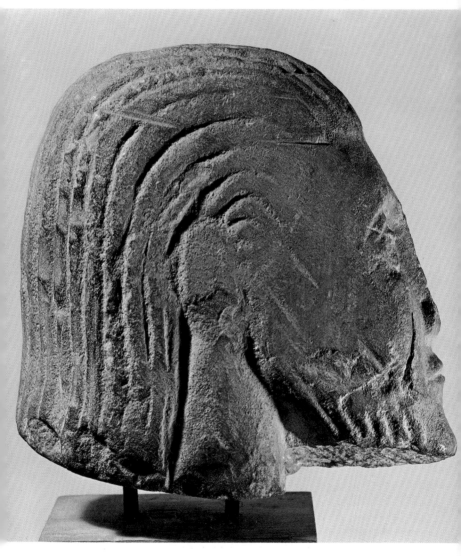

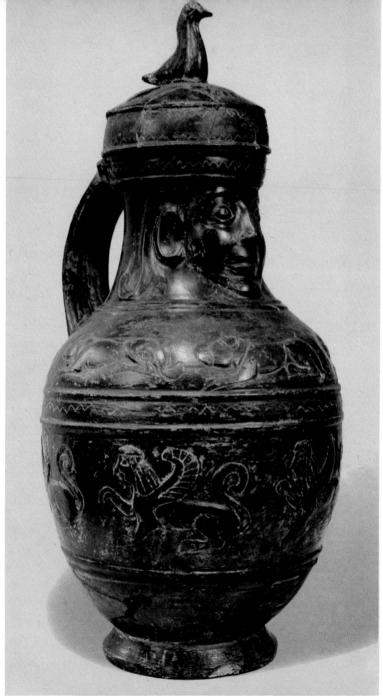

104

60 *Italic art : Vase made of thin bronze sheets (Villanovan culture). Bologna, Civic Museum.*

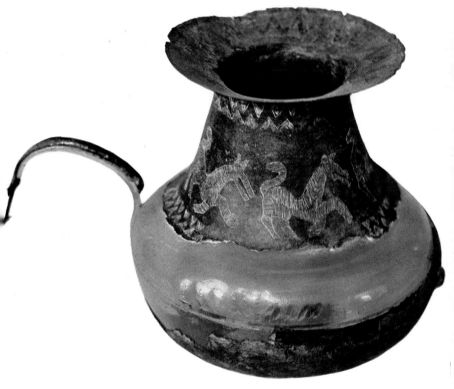

59 *Etruscan art :* Bucchero *vase from Chiusi (seventh–sixth century BC). Florence, Archaeological Museum.*

58 Italic art: The Gozzadini Head (Villanovan culture).
Bologna, Civic Museum.
Although Villanovan art is almost always decorative in
character, there are occasional attempts at a higher form
of sculpture, as, for example, in the Gozzadini head.

59 Etruscan art: *Bucchero* vase from Chiusi (seventh–
sixth century BC). Florence, Archaeological Museum.
In the seventh century the high cost of bronze made it
accessible only to a few and resulted in the production of
a type of pottery which imitated burnished metal both in
colour and polish. It was known as *bucchero* and was a
speciality of the Clusium (Chiusi) area.

60 Italic art: Vase made of thin bronze sheets (Villanovan
culture). Bologna, Civic Museum.
This beautiful and finely decorated vase, made of thin
sheets of bronze, was found in the Arnoaldi Cemetery,
Bologna.

61 Etruscan art: Canopic urn on a seat (seventh century
BC). Florence, Archaeological Museum.
This cinerary urn of reddish clay is placed upon a seat with
a curved back. The body of the vase is decorated with
flowers and geometric patterns. The lid is a stylized repro-
duction of the dead man's head.

62 Etruscan art: Ivory arm from the Barberini Tomb,
Palestrina (seventh century BC). Rome, Villa Giulia
Museum.
The Barberini Tomb at Palestrina yielded a number of
immensely valuable objects and in particular delicately
carved ivories. Amongst these are the famous ivory arms
which may have been intended as handles for mirrors,
fans and other objects.

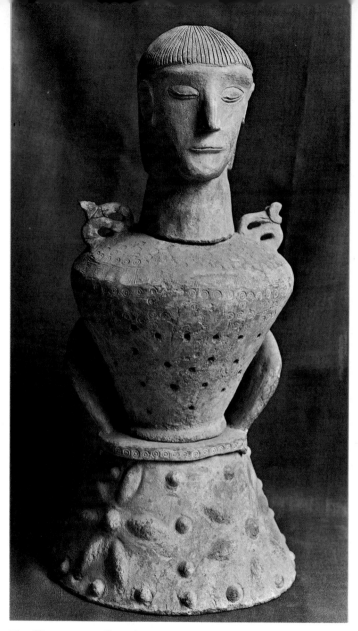

61 *Etruscan art : Canopic urn on a seat (seventh century BC).*
Florence, Archaeological Museum.

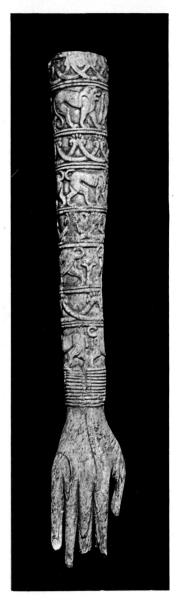

62 *Etruscan art : Ivory arm from
the Barberini Tomb, Palestrina
(seventh century BC). Rome, Villa
Giulia Museum.*

Greek colonization (eighth century BC) intro-
duced into Italy painted pottery which was
promptly copied in the new colonial centres.
The Apulo-Salentine culture in particular,
which reached its peak between the seventh and
fifth centuries BC, developed a tradition of
extremely original forms and decoration, often
polychrome.

Frequent contact with other, more advanced
civilizations also left significant traces on the
crafts and artistic achievements of these peoples.
Contact was mainly through maritime trade or
migrations. It is easy to distinguish Meso-
potamian, Egyptian and Phoenician elements
in objects made in the ninth, eighth and seventh
centuries in Italy. There are so many eastern
elements in the Umbro-Sabellian civilization
that it is in fact labelled an 'oriental' culture.
The influence of Greek culture was mainly felt
in Sicily and the southern region of Italy where
groups of Greeks settled after an economic crisis
in their own country, and where their culture
became an offshoot of Greek civilization. Since
these settlers were of Doric origin, the style of
Greco-Italic art bears the stamp of their home-
land.

Side by side with a real Greek culture introduced
by immigrant Greek artists, there developed and
flourished in Sicily and Magna Graecia (the name
given later to the southern part of the Italian
peninsula) an indigenous school of art which
was nevertheless quite close to the style and
forms of Greek art. The ruins of Doric temples
at Paestum, Agrigento, Segesta and other places,

and the archaic Doric sculptures of the metopes of the temple of Selinunte, must be considered as examples of Greek art proper; but the pottery, small bronzes, decorated objects and so forth are typical expressions of indigenous Italic art, despite their clear affinity with Greek models.

Compared with Greek-made objects, the small statues and painted vases of Italic artists show thicker, clumsier outlines and more rigid shapes, natural to an agricultural civilization; but the art of Magna Graecia, like that of Greece itself, certainly shows signs of a progressive evolution, the styles becoming more assertive and mature as time goes on. The small bronze objects of the fourth and third centuries contain elements of sophistication similar to those of early Hellenistic art. They are always, however, conceived on a different plane, with a certain

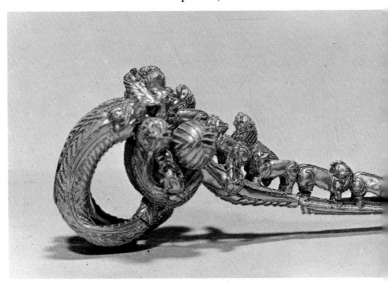

63 *Etruscan art : Gold fibula. Paris, Louvre.*

provincial quality to them, characteristic of the whole of Italic art.

Moving northwards, there is even stronger evidence of foreign influence in local crafts. The decorated pottery of Campania, with its bright colours and naive decorations, is clearly influenced by late Mycenaean and archaic Greek wares. The Apulian paintings discovered in Ruvo, on the other hand, show signs of Etruscan influence in that region; and the numerous statuettes of warriors, gods and other personages, despite the roughness of their workmanship, display strong affinities with either Greek or Asiatic models. Certain remarkable examples of gold decoration are also strongly oriental in character.

Further north the weapons, vases, jewellery and stone stelae with reliefs show, by contrast, a

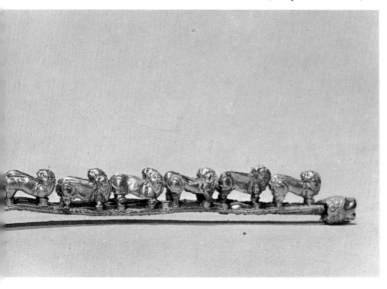

63 Etruscan art: Gold fibula. Paris, Louvre.
Among the most characteristic Etruscan jewellery was the fibula, a kind of large safety pin, made of bronze or very often of precious metals.

64 Etruscan art: Bow-shaped gold fibula from the Regolini-Galassi Tomb, Cerveteri (seventh century BC). Vatican City, Gregorian Museum.
The disc is decorated with five lions surrounded by a double border of small bows woven together and topped by rosettes. The convex bow is decorated alternately with geese and leaping lions.

65 Etruscan art: Situla from the charterhouse (beginning of the fifth century BC). Bologna, Civic Museum.
The first decorative band shows marching soldiers, the second a religious procession, and the third and fourth scenes of domestic and rural life.

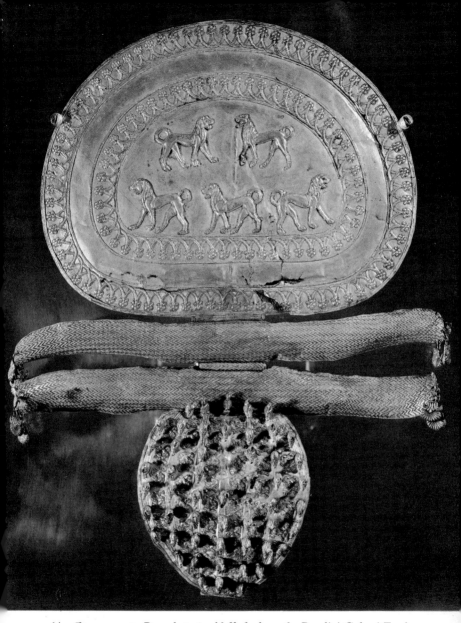

64 *Etruscan art : Bow-shaped gold fibula from the Regolini-Galassi Tomb,
Cerveteri (seventh century BC). Vatican City, Gregorian Museum.*

113

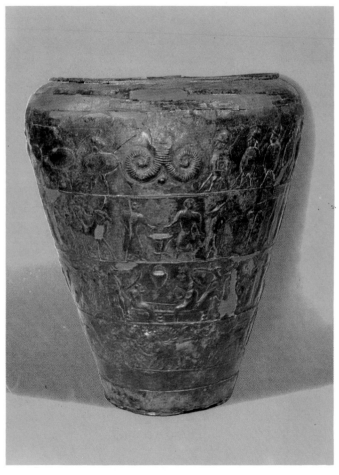

65 *Etruscan art : Situla from the charterhouse (beginning of fifth century BC). Bologna, Civic Museum.*

connection with Nordic cultures. In the fourth century Celtic civilization, which had spread all over central Europe since the Bronze Age, irrupted into Italy. It was the Celts who introduced the taste for geometric patterns such as spiral, scroll and serpentine decoration, and many Italic objects show their influence.

Perhaps the most interesting of the early civilizations of Italy was the so-called Villanovan culture (eighth century BC). The Villanovans had settled in the regions lying between the Appenines in Tuscany and Emilia and the Po valley; later the Etruscans were to occupy the same territory (then known as Etruria). They were an agricultural people with a fairly well developed economy, and although craftsmen rather than artists they produced work of sound, sometimes outstanding, quality. The Villanovan villages and necropoles have yielded various objects for domestic use – including terracotta and bronze vessels, and lidded urns in the shape of a double horn, in which were kept the ashes of the dead. The structure of the vases is often quite complex: some are shaped like animals, others are in human form; sometimes there is a mixture, as in the case of a vase representing a mounted warrior. The decoration is mostly geometric but always very free and lively. In the middle period of Villanovan culture (which probably coincided with the height of its economic prosperity), there is an increasing use of bronze objects among the funerary furnishings. Among these the most characteristic is the censer which is sometimes beautifully decorated.

The Villanovan culture too shows signs of having come into contact with other contemporary civilizations, both Mediterranean and Nordic; but such influences do not detract from the originality so evident in the objects thus far discovered.

THE ETRUSCANS

Details of the Villanovan culture are still obscure because we know nothing of the history of the people who created it. The same is true of the Etruscan civilization which flourished after it in the same part of the peninsula. The most important Etruscan cities were built on the site of Villanovan settlements – initially without any significant modifications. The mystery surrounding the origins of the Etruscans is perhaps the most hotly debated problem since antiquity and one which has baffled generations of scholars in modern times. None of the theories which have been put forward (such as their being of Greek or Italic origin, or having come from central Europe by way of the Alpine passes) has gathered enough evidence to overwhelm all the objections to it. Herodotus mentions a story about the Lydians, a people of Asia Minor:

'The Lydians say that under the rule of King Atys there was a great famine in Lydia; for a while the people faced it but when it did not stop they tried to overcome it . . . But the famine increased instead of diminishing and the king divided his people into two groups and drew lots to decide which of the

two should leave the country. He placed himself at the head of the group which was to remain and put his son Tyrrhenius in charge of the other. The exiled Lydians marched down to Smyrna, built themselves some ships and sailed away in search of a new land and means of subsistence. After skirting many countries they arrived in the land of the Umbrians, where they founded a city in which they still live to this day. However they changed their name from 'Lydians' to 'Tyrrhenians', after their king.'

'Tyrrhenians' was indeed what the Greeks called the Etruscans. On the other hand, according to Diogenes of Halicarnassus, a writer who lived in Rome in the time of Augustus and author of *Roman Antiquities*, a monumental work on early Roman history, the Etruscans were an indigenous Italic race.

One fairly confident assertion is that Etruscan civilization, though undoubtedly containing Asiatic and Aegean elements, clearly has firm links with the indigenous cultures of Italy among which it developed. By the time of their first appearance in history the Etruscans were already established in the area between the Arno and the Tiber, a region rich in minerals, especially ferrous minerals, and ideal for cultivation and communications. Very soon, thanks to the progressive growth of maritime traffic and contact with Greek civilization in southern Italy, the primitive Villanovan phase was overtaken and the Etruscans reached a new stage in their cultural development, characterized by elements

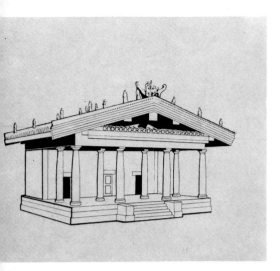

Reconstruction of an Etruscan temple of the sixth century. Etruscan temples were usually built of wood and decorated with terracotta reliefs and statues.

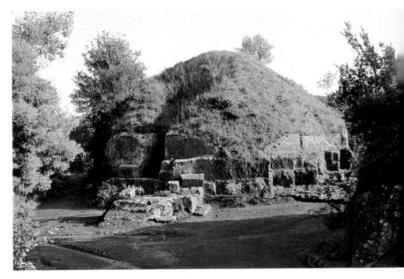

66 *Etruscan art : Circular tomb near Cerveteri.*

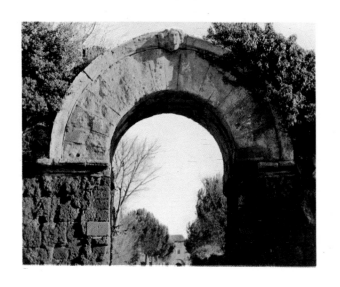

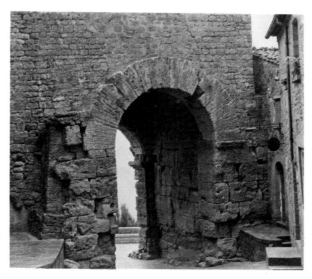

67 *Etruscan art : The Jupiter Gate (top), S. Maria di
Falleri (third century BC). Arch gate (bottom), Volterra
(fourth century BC).*

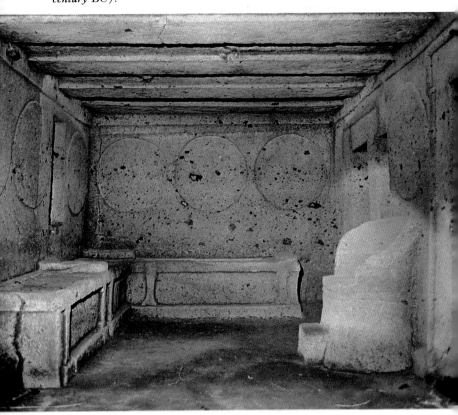

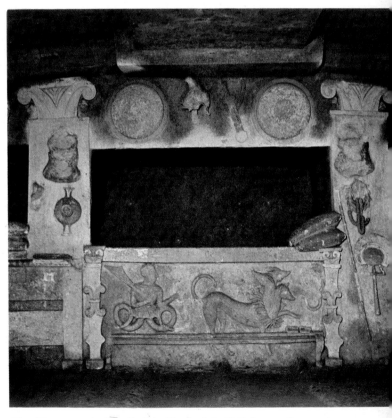

69 *Etruscan art : Detail of the Tomb of the Reliefs near Cerveteri (second century BC).*

66 Etruscan art: Circular tomb near Cerveteri. The outside of the tomb is marked by a large tumulus of earth, shaped like a grassy knoll; this is usually reinforced by a circular base sometimes carved out of the rock and sometimes made of large slabs of stone.

67 Etruscan art: The Jupiter Gate (top), S. Maria di Falleri (third century BC). Arch gate (bottom), Volterra (fourth century BC).
The great innovation of Etruscan art was the adoption of the arch which was subsequently passed on to the Romans.

68 Etruscan art: Tomb of the Shields and Seats near Cerveteri (seventh century BC).
Like many ancient peoples the Etruscans believed in life after death and attempted to recreate the atmosphere of earthly life in the decoration of their tombs.

69 Etruscan art: Detail of the Tomb of the Reliefs near Cerveteri (second century BC).
The originality of the decorations of the Tomb of the Reliefs sets it apart from the others: its interior reproduces the structure and furnishings of a private house.

70 Etruscan art: Fresco from the Tomb of the Leopards, Tarquinia (c. 470 BC).
The back of Etruscan tombs is decorated with scenes of banquets in which the dead and their family take part.

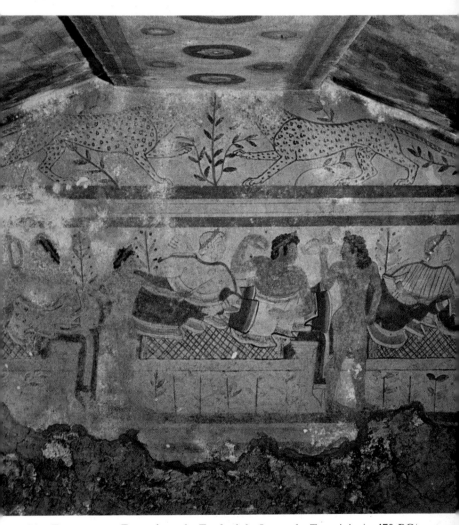

70 *Etruscan art : Fresco from the Tomb of the Leopards, Tarquinia (c. 470 BC).*

borrowed from Asia and the Aegean. This 'oriental' phase, which lasted from the end of the eighth century BC to the sixth, saw the first flowering of Etruscan architecture, the establishment of the first urban settlements and the expansion of maritime trade, in which the Etruscans competed with the Greeks and the Phoenicians. The influence of Asiatic and Aegean culture can be seen in the decorative arts (for example in the superb jewellery found in the Regolini-Galassi Tomb at Cerveteri) and in painting (the Tomb of the Lions and the Painted Animals at Cerveteri, and the Campana Tomb at Veii).

The Etruscan cities reached the height of their power and splendour between the seventh and fifth centuries BC. They were autonomous, governed by a ruler known as a *lucumon* and, for reasons of defence, built on high ground. The source of their prosperity was commerce. This is especially true of the southern cities (Cerveteri, Vulci, Veii, Tarquinia). The northern cities were poorer and chiefly devoted to agriculture.

It was the demands of trade which largely determined Etruscan expansion both in the south and in the north, as is evident from the isolated enterprises characteristic of Etruscan colonization. Livy writes that the Etruscans occupied the whole of the plain of the Po up to the Alps, except for the territory occupied by the Veneti. It is impossible to check this statement, which may be an over-estimate. The Etruscan cities in the Po valley of which we have

any knowledge are Felsina (modern Bologna), Mantua, Marzabotto, Adria and Spina (the latter two being the major Etruscan centres of commerce, open to trade with Greece and harbouring a large Greek colony), and Melpum, so named by the Romans but not yet discovered. In the north, Etruscan colonies were eventually overrun by the Celtic invaders. In the south, in Campania, where cities such as Capua, Nola, Sorrento, Pompeii and Herculaneum were founded, the commercial domination of the Etruscans was strongly opposed by the Greek colonies and ended in the waters of Cumae, where the Etruscan fleet was defeated by the combined forces of Cumae and Syracuse (474 BC). The Etruscan domination of Campania was followed by their extension into Latium, on the other side of the Tiber. It is now known that the last three kings of Rome belonged to an Etruscan dynasty. The Emperor Claudius, who was an expert on ancient Italic history, knew of an Etruscan legend according to which a group of Etruscans under the leadership of Cele Vibenna, Aule Vibenna and Mastarna, settled on one of the Roman hills. Mastarna then probably ruled over Rome under the name of Servius Tullius. This Etruscan tradition is endorsed by the paintings in the François Tomb at Vulci, where the three personages are represented in a victory against the Romans. The cause of the downfall of the Roman monarchy was a national insurrection led by Tarquinius with the help of Lars Porsenna, *lucumon* of Clusium (Chiusi), against the foreign invaders,

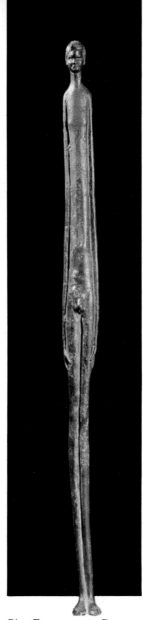

71 *Etruscan art : Bronze*
statuette. Volterra,
Guranacci Etruscan
Museum.

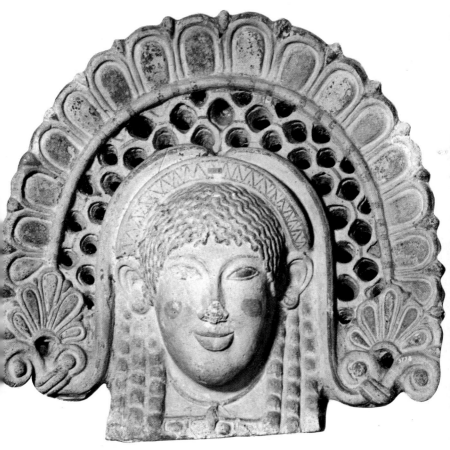

72 *Etruscan art : Antefix from the temple of Juno Sospita, Lanuvium (sixth–fifth century BC). Rome, Villa Giulia Museum.*

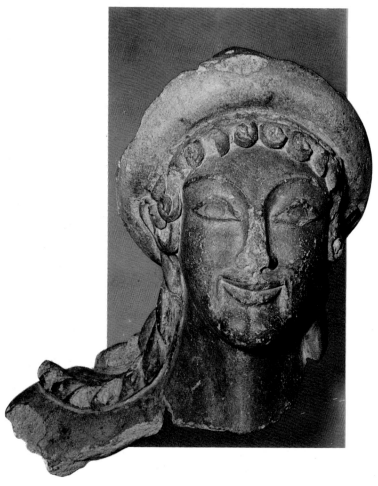

74 *Etruscan art : Apollo of Veii (c. 500 BC). Rome, Villa Giulia Museum.*

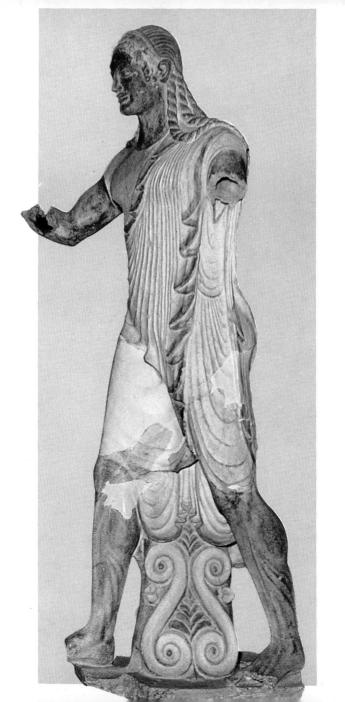

129

71 Etruscan art: Bronze statuette. Volterra, Guranacci Etruscan Museum.
Masses of votive bronze statuettes were found in Etruscan sanctuaries, many of them showing an exaggerated elongation of limbs and body.

72 Etruscan art: Antefix from the temple of Juno Sospita, Lanuvium (sixth-fifth century BC). Rome, Villa Giulia Museum.
Etruscan temples were decorated with terracotta ornaments, the most original of which were the antefixes; these often consist of a head inserted into an aureole or a kind of shell. The example illustrated here was finished with touches of colour.

73 Etruscan art: Terracotta head of Hermes (*c.* 500 BC). Rome, Villa Giulia Museum.
This head of Hermes was one of a group decorating the eaves of the temple of Portonaccio, Veii.

75

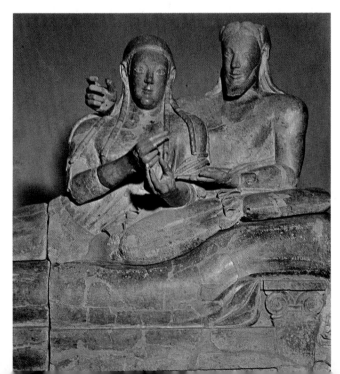

74 Etruscan art: Apollo of Veii (*c.* 500 BC). Rome, Villa Giulia Museum.
The terracotta statue of the Apollo of Veii is one of the most striking examples of the art of Vulca and his school. The style is mobile and sensitive, full of dynamic impetus.

75 Etruscan art: Sarcophagus of a married couple (second half of the fifth century BC). Rome, Villa Giulia Museum.
The couple originally held two goblets in their hands, probably raised as a toast.

76 Etruscan art: Cinerary urn decorated with reliefs. Volterra, Guranacci Etruscan Museum.
Greek influence on Etruscan art is evident even in relief decoration, the subject-matter of which was often taken from Greek mythology.

76

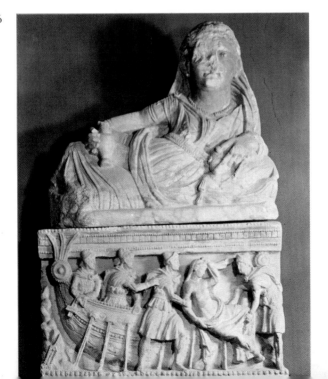

its aim being to regain control of Rome.

The battle of Aricia in 504 BC, won by the Latins with the help of Aristodemus of Cumae, marks the end of Etruscan domination over Latium and the first step towards the loss of Campania.

By the seventh century Etruscan art was in full flower. Temples were erected, and there were flourishing schools of sculpture and painting. The marble quarries of Carrara, which were to be so widely used in Roman times, were not discovered by the Etruscans, for there are few traces of marble in their buildings. Nor was stone a popular medium, being chiefly reserved for tombs and military constructions. Private houses and temples were usually built of more fragile materials, such as wood, mud or terracotta. This is why the only Etruscan buildings which have survived are tombs and fortifications. Since the cult of the dead was of paramount importance among the Etruscans, the tombs are amongst the richest and most interesting examples of their culture.

The oldest chamber tombs, dating from the seventh century, are often in the shape of a round chamber surmounted by a false dome made of stones arranged in concentric circles, projecting one above the other. There is evidence of Mycenaean influence in this type of roof. The majority of Etruscan tombs, however, are of the characteristic tumulus structure – a central chamber topped by a barrow of earth surrounded with a circular stone base. The plan of the central chamber differs according to the tomb and

may have a variety of areas and corridors. The burial chamber is furnished and adorned as if it were a proper living quarter. These tombs are almost always underground and marked by tumuli, while others are carved into the rocks on hillsides. Among the underground tombs, one of the most famous is the Tomb of the Reliefs near Cerveteri, where the pilasters and walls are decorated with painted plaster reliefs representing everyday objects, supposedly of use to the departed in the after-life.

Hardly anything remains of the ancient temples which were almost always dedicated to the three major Etruscan deities – Jupiter, Juno and Minerva. It is possible, however, to reconstruct their form from the descriptions left of them by Roman writers such as Vitruvius, and from small terracotta models which had been used as votive offerings. They were rectangular in shape, with a deep porch adorned with a double row of columns on the façade and a *cella* divided into three parts, for the worship of the three deities. The temple was built onto a high base, or podium, with a narrow flight of stairs on the front. The Etruscan temple was thus quite different from contemporary Greek temples both in ground-plan and decoration. The so-called Tuscan columns had plain shafts, as opposed to the fluted shafts of Greek columns, a round base and a capital with a double-curve moulding. The pediment was decorated with bright polychrome slabs of terracotta. Typical of the Etruscan temple were the antefixes, terracotta ornaments fixed on the roof along the eaves, at the edge of the roof tiles,

usually on the longer sides of the temple but often also on the façade, at the base of the tympanum.

The antefixes were usually cast in moulds and their value on the whole is that of fine pieces of craftsmanship rather than works of art. Their decoration is varied and ranges from floral motifs (palmettes and lotus flowers) to mythological figures, heads of Gorgons and Sileni, and oriental figures such as lions, griffins or fantastic birds.

The main difference between Greek and Etruscan architecture is the latter's introduction of the arch, which takes the place of pilasters and architrave. The Etruscan arch consists of a vigorous structure based on the mutual pull of the wedge-shaped blocks of stone from the central keystone.

77

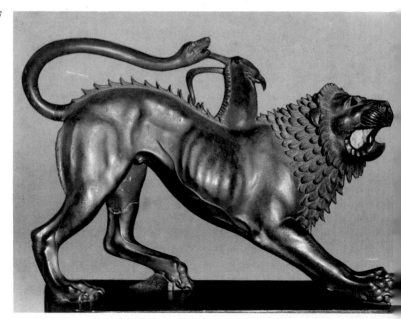

For some time it was thought that the Etruscans had actually invented the arch, but it is now known that it had earlier been used in Mesopotamia and Asia Minor. The Etruscans, however, must be given credit for adopting the idea and transmitting it to the Romans who developed and elaborated it with such skill and ingenuity for every type of constructional work. Fine examples of the Etruscan arch in the remains of walls which once fortified Etruscan cities are the famous Volterra Gate and the Porta Marzia and the Augustan Gate, both in Perugia. The most ancient Etruscan sculptures date from the seventh century BC, but only in the sixth century do they begin to acquire any real artistic merit. They are mainly cinerary urns, also known as canopic urns, and came mainly from the Clusium district. These terracotta urns,

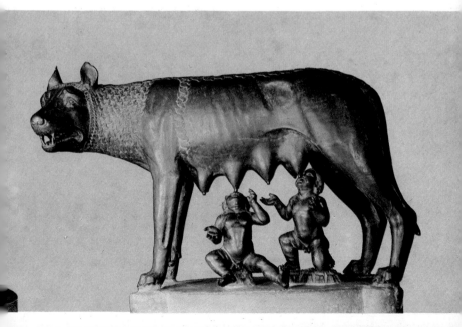

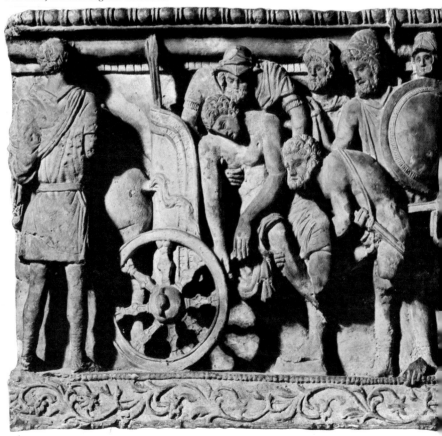

78 *Etruscan art : Hector's body being carried away from the battlefield ; detail of a cinerary urn from Volterra (third century BC). Florence, Archaeological Museum.*

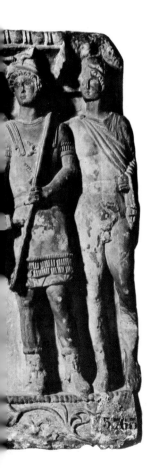

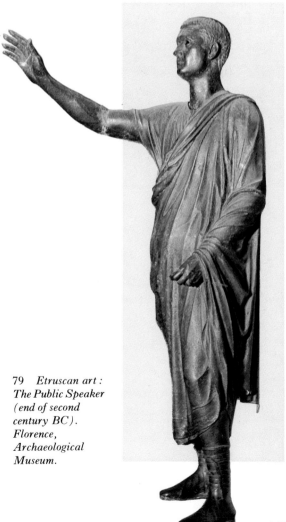

79 Etruscan art :
The Public Speaker
(end of second
century BC).
Florence,
Archaeological
Museum.

137

77 Etruscan art: The Arezzo Chimaera and the Capitol She-wolf (fifth century BC). Florence, Archaeological Museum and Rome, Conservatori Museum.
The chimaera from Arezzo and the she-wolf from the Capitol are the two most famous bronzes in Etruscan art. The twins, Remus and Romulus, are a Renaissance addition.

78 Etruscan art: Hector's body being carried away from the battlefield; detail of a cinerary urn from Volterra (third century BC). Florence, Archaeological Museum.
The urn is said – though without proof – to have belonged to Michelangelo. According to some scholars the composition of the relief inspired his *Pietàs*.

79 Etruscan art: The Public Speaker (end of second century BC). Florence, Archaeological Museum.
The bronze statue of the public speaker, Aule Metellis, with its austere face and eloquent gesture, heralds the best of Roman portraiture, characterized by a synthesis of realism and expressiveness.

80 Etruscan art: Fresco from the Tomb of the Lionesses (detail), Tarquinia (*c.* 520 BC).
The walls of the Tomb of the Lionesses at Tarquinia are decorated with joyous scenes of dancing in which the figures of the dancers glow with a vitality due both to the design and to the bright colours with which they are painted.

81–82 Etruscan art: Frescoes from the Tomb of the Augurs (details), Tarquinia (*c.* 530 BC).
The name of this little tomb in Tarquinia is derived from the two solemn characters on the back wall, raising their arms as if in a gesture of sorrowful dismissal. The side walls are vividly painted with scenes of athletic contests which used to be given in honour of the dead.

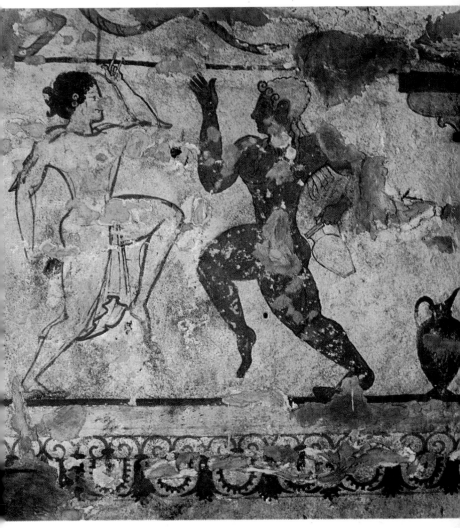

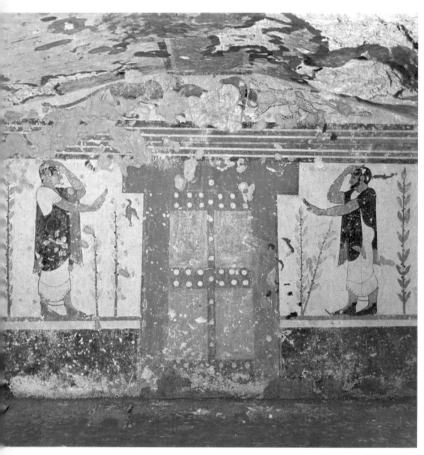

81 *Etruscan art : Fresco from the Tomb of the Augurs (detail),*
Tarquinia (c. 530 BC).

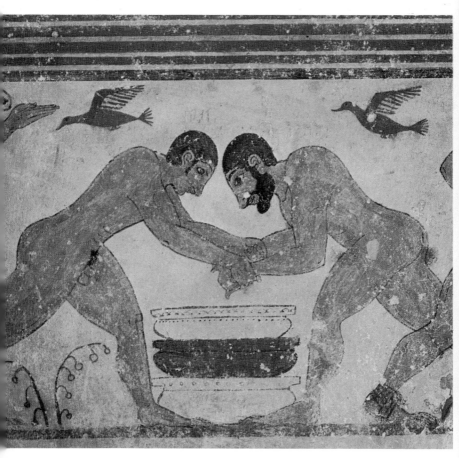

82 *Etruscan art : Fresco from the Tomb of the Augurs (detail), Tarquinia (c. 530 BC).*

often of huge dimensions, are roughly anthropo-
morphic, with the lid forming the head and the
handles shaped like bent arms. They are among
the most original expressions of Etruscan culture
and, as they were meant to represent the portrait
of the dead, even though in a stylized, geometric
form, they can be regarded as the first genuine
attempts at portraiture in Italy. The finest
among these urns show an amazingly 'modern'
treatment of the face, with rough but vivid
features. In general, Etruscan art, which is less
intellectual in concept but more instinctive and
dramatic than Greek art, has the greater
immediate appeal.

Later, towards the middle of the sixth century,
there appeared a type of cinerary urn with the
dead person shown seated upon its lid (examples
include the statue of *Mater Matuta* in Florence
and several in Palermo Museum). Here, in the
more organically composed shape, there is
evident influence of archaic Greek sculpture.

Ionic influence is evident in the characterization
and drapery of the statues by the only Etruscan
artist whose name is known – Vulca, who made
the figures for the temple of Portonaccio at Veii.
He was later asked to produce statues for the
Capitoline temple in Rome. In his famous
Apollo of Veii, Ionic traits are combined with a
purely Etruscan vivacity of expression which is
emphasized by the striding movement of the
statue. Here the 'archaic smile' becomes almost
an insolent sneer. The fine antefixes of the Porto-
naccio temple may have been modelled by hand
in Vulca's workshop.

The turn of the sixth century was a particularly fruitful period in Etruscan art. Bronze vases and other objects, such as the famous situla found in the charterhouse at Bologna, are of a high standard. The essence of the Etruscan spirit comes to light in the funerary sculptures, stelae and statues of the dead on the lid of sarcophagi. The sarcophagi were usually made of painted terracotta and the lid showed the dead man, life-size and half-reclining, often with his wife by his side. The lower part of the body is flattened and the bust shows vigorous modelling, as does the vivid, sharp face. The sense of relief is strong, the features not individualized; the general effect is a coherent mixture of fantasy and realism.

From Veii comes a very famous bronze, the She-wolf of the Capitol, a work of surprising vitality, with its savagely expressive head and simple, synthetic structure. There are similar elements in the Arezzo Chimaera, another famous bronze, which is slightly later in date.

Etruscan contact with the Greek world was intensified in the fourth century. The sculpture of Scopas and Lysippus appealed to the Etruscan temperament and their influence can be seen in the fine bust of a young god, probably Apollo, part of the decoration of a temple in Civita Castellana and now in the Villa Giulia Museum. The Etruscans were also influenced by some Hellenistic traits.

In Etruscan art of the later period there are many cinerary urns, decorated on the main side (and sometimes on the two shorter sides) and with

83 *Etruscan art : Fresco from the Tomb of Hunting and Fishing (detail),*
Tarquinia (520–10 BC).

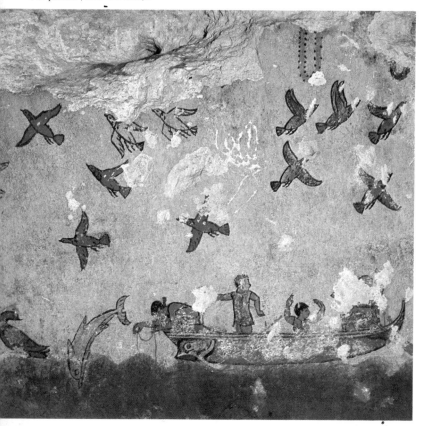

84 *Etruscan art: Fresco from the Tomb of Hunting and Fishing (detail),
Tarquinia (520–10 BC).*

83–84 Etruscan art: Frescoes from the Tomb of Hunting and Fishing (details), Tarquinia (520–10 BC).
The decoration of the Tomb of Hunting and Fishing is unique in the history of Etruscan painting. The tomb is divided into two chambers, the frescoes in the first representing the usual banqueting scene, the walls of the second turning into a huge seascape in which man plays only a secondary role.

85 Etruscan art: Fresco from the Tomb of the Triclinium (detail) (*c.* 470 BC). Tarquinia, National Tarquinian Museum.
The magic flautist casting his spell over trees and birds is perhaps the most evocative image in the whole of Etruscan painting.

86 Italic art: Funeral dance (detail); fresco from a tomb at Ruvo (end of fifth century BC). Naples, National Archaeological Museum.
This powerful work by an exceptionally gifted Italic artist is imbued with an atmosphere of gloom and tragedy, due to the rhythmic repetition of figures, the violent colours and harsh profiles of the dancers.

87 Etruscan art: Fresco from the Tomb of the Triclinium (detail) (*c.* 470 BC). Tarquinia, National Tarquinian Museum.
A joyous procession of musicians and dancers through delicate young trees in bloom; the figures, all tender colours and graceful lines, seem lost in a dream.

88 Etruscan art: Fresco from the Tomb of the Underworld (detail), Tarquinia (end of fourth century BC).
The frescoes of the Tomb of the Underworld, depicting life after death, are steeped in gloom. The detail reproduced here shows the young Velia, a member of the family, looking aghast at this vision of an underworld inhabited by monsters.

*Etruscan art : Fresco from the Tomb of the Triclinium (detail),
(c. 470 BC). Tarquinia, National Tarquinian Museum.*

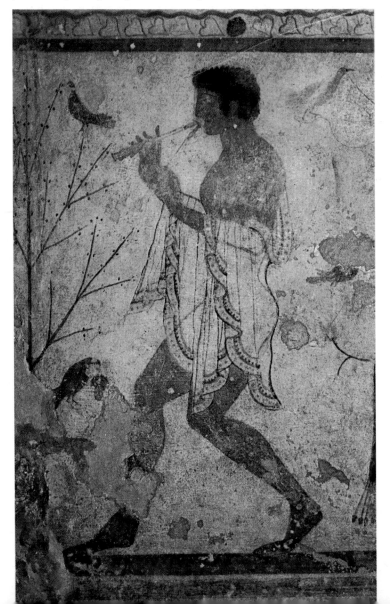

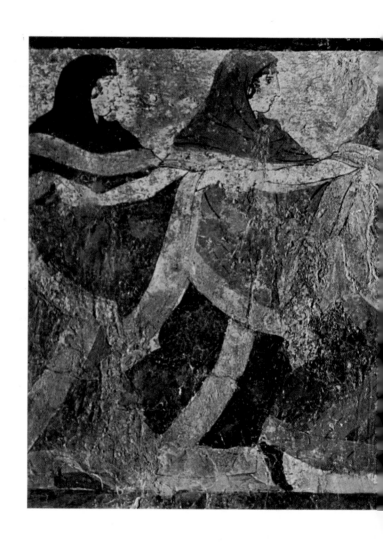

148

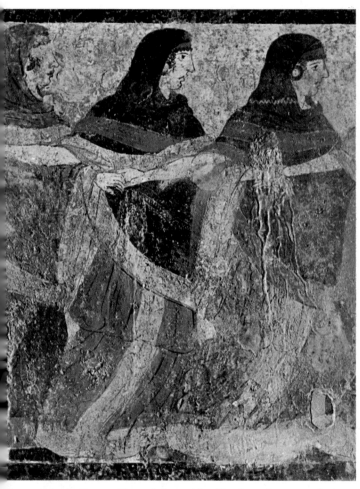

86 *Italic art : Funeral dance (detail) ; fresco from a tomb at Ruvo (end of fifth century BC). Naples, National Archaeological Museum.*

87 *Etruscan art : Fresco from the Tomb of the Triclinium (detail),*
(c. 470 BC). Tarquinia, National Tarquinian Museum.

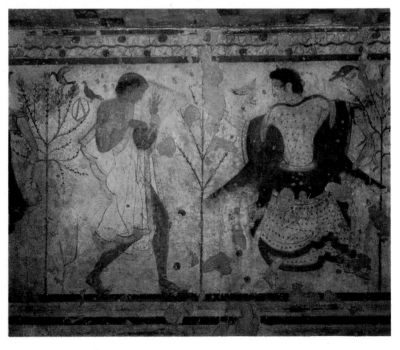

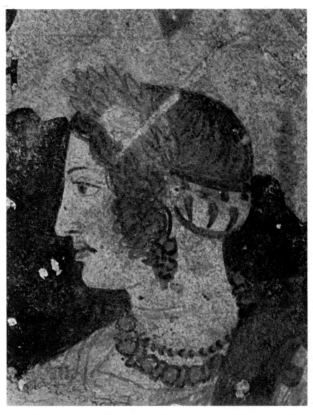

88 *Etruscan art : Fresco from the Tomb of the Underworld
(detail), Tarquinia (end of fourth century BC).*

151

effigies of the dead on the lid, which have been described as 'a precious document of Hellenistic art'. The main centres of production were Clusium (some of the urns there show evidence of the *trompe-l'oeil* technique used in some Hellenistic painting), Perugia, Tarquinia and, above all, Volterra, where the urns display the sudden return to Classicism in Hellenistic art during the second century BC. There are also a few superb portraits such as the imperious Brutus from the Capitol (the very prototype of a Roman citizen in the early days of the Republic) and the famous Public Speaker, with his simple, serene stance. The latter is the first example of a type of statuary cherished by the Romans up to the Augustan age, the same arm gesture being repeated in the Augustus of Prima Porta.

Unlike the Greeks the Etruscans have left us extremely rich and varied examples of their painting, thanks to the tradition of decorating with frescoes the inner walls of tombs, so that the dead could look at the most pleasant aspects of their earthly existence – banquets, games, dancing and sports. Religious or mythological scenes are much rarer. The oldest known frescoes date from the seventh century and show an oriental fantasy in the mixture of strange plants, animals and stylized figures, painted with a crude use of contrasting colours. There is a certain amount of Greek and Corinthian influence (for Greek vases were now freely imported) and these grow stronger in the sixth century.

A great deal of the painted pottery found in

Etruscan tombs was in fact directly imported from Greece. Typically Etruscan, however, is the so-called *bucchero* ware, uniformly black both outside and inside. Prior to *bucchero* there had been a type of black impasto pottery in central Italy during the Bronze and Iron Ages, which had never reached the quality and technique of Etruscan *bucchero*.

There have been many theories about the way in which the Etruscans treated the clay to obtain the uniform black of *bucchero*. One suggestion is that they mixed the clay with charcoal powder, another that they devised a method of fumigation by which red ferric oxide, which is present in clay, could be transformed into black ferrous oxide.

The first examples of *bucchero* appeared about the middle of the seventh century in Cerveteri and Tarquinia. At a later date Clusium seems to have had the monopoly in the production of this type of pottery which by then was much heavier and richly decorated. The production of *bucchero* ceased completely in the fifth century.

It was from the decoration of Greek vases that the Etruscans learnt the art of drawing figures in a neat line, as well as the convention by which male figures were painted red and female figures white, as in red-figured Greek pottery. But alongside certain Greek elements are others which are typically Etruscan – notably a taste for barely suggested landscapes and the use of strong colours, used in juxtaposition according to the artist's whim. Additionally, the harmonious rhythm of Greek painting is replaced by

a vivid, narrative style of more immediate appeal. All these traits can be seen in the numerous tombs at Tarquinia which date from the sixth century – the Tombs of the Bulls, the Augurs, the Lionesses, Hunting and Fishing, the Bacchantes and the Baron, all of which are decorated with frescoes based on everyday scenes of gay or licentious dancing, games and religious ceremonies. Particularly pleasing is the tomb decorated with scenes of hunting and fishing, with its boat lost in a sea brimming with fish, under a sky alive with birds.

In the fifth-century Tombs of the Leopards and the Triclinium at Tarquinia, Etruscan painting becomes more sophisticated. In the Tomb of the Triclinium, perhaps the finest of all, the elegant figures are delicately painted.

A sensible change comes over painting as well as sculpture from the end of the fifth century, coinciding with the waning of Etruscan political power, overwhelmed by the expansion of Rome. The painting of the fourth and third centuries is affected by this period of crisis and the subject-matters change, the joyous scenes of banqueting giving way to melancholy scenes, painted in dull or burnt colours. Examples of these can be seen in the Tomb of the Underworld at Tarquinia and in the François Tomb at Vulci where the frescoes contain monsters and demons. With the approach of the first century, Etruscan art gradually loses its formal characteristics to become part of Roman art. But the Etrusco-Italic spirit was not entirely crushed and it continued to flourish in smaller centres.

BIBLIOGRAPHY

Greek Art

P. E. ARIAS, *Skopas, Rome, 1952*
G. BECATTI, *Problemi fidiaci, Florence-Milan, 1951*
Scultura greca, vol II, Milan, 1961
R. BIANCHI BANDINELLI, *Organicità e Astrazione,*
Milan, 1956
M. BOWRA, *Classical Greece, New York, 1965*
P. F. JOHNSON, *Lysippos, Duke University Press, 1927*
C. PICARD, *Manuel d'archéologie grecque. La sculpture,*
5 volumes, 1935–63
K. SCHEFOLD, *Art of Classical Greece, New York, 1967*
B. SCHWEITZER, *Alla ricerca di Fidia, Milan, 1967*
E. VERGARA-CAFFARELLI, *Studio per la restituzione*
de Lacoönte

Etruscan and Italic art

Catalogue of the exhibition of late Etruscan sculpture from
Volterra, edited by C. Laviosa, Florence, 1964
R. BLOCH, *Etruscan Art, New York, 1966*
A. FROVA, *L'arte etrusca, 1957*
M. PALLOTTINO, *Etruscan Painting, New York, 1952*
E. RICHARDSON, *Etruscan Sculptures, New York*

INDEX OF ILLUSTRATIONS